# AROUND HAYES

## THROUGH TIME

Philip Sherwood &

Hayes & Harlington Local History Society

AMBERLEY PUBLISHING

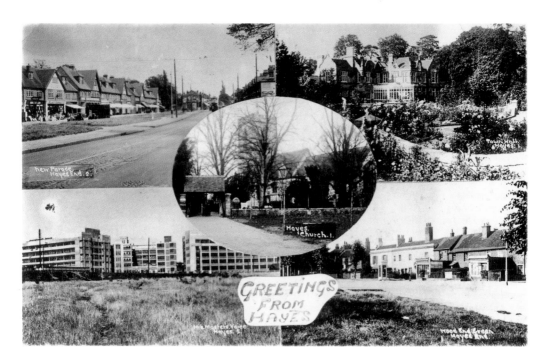

A 1930s picture postcard of Hayes.

*Dedicated to the memory of Terry White (1927–2012), the first chairman and later the president of the Hayes & Harlington Local History Society, without whose efforts over many years in building up the society's collection of photographs it would not have been possible to produce this book.*

First published 2013

Amberley Publishing
The Hill, Stroud
Gloucestershire, GL5 4EP

www.amberley-books.com

Copyright © Philip Sherwood, 2013

The right of Philip Sherwood to be identified as the
Author of this work has been asserted in accordance
with the Copyrights, Designs and Patents Act 1988.

ISBN 978 1 4456 1444 1 (PRINT)
ISBN 978 1 4456 1459 5 (EBOOK)

British Library Cataloguing in Publication Data.
A catalogue record for this book is available from
the British Library.

Typeset in 9.5pt on 12pt Celeste.
Typesetting by Amberley Publishing.
Printed in the UK.

# Introduction

The first recorded mention of Hayes, then known as 'Hese', was in the ninth century. The name was derived from an Anglo-Saxon word meaning 'moorland covered with brushwood'. For centuries it remained nothing more than a rural backwater until the Grand Union Canal (then known as the Grand Junction Canal) was cut through the area in 1794. This gave rise to the first industry to appear in the area, as the presence of brickearth on either side of the canal led to the establishment of brickworks, with the finished bricks being shipped via the canal to London. The railway arrived in the 1830s but the station at Hayes did not open until 1864. Even then the population remained small with just over 2,500 living in the parish according to the 1901 census.

However, because of the good links to London offered by the railway and the canal, between 1900 and 1920 there was a huge expansion of the town, with the arrival of several well-known manufacturing companies such as the Gramophone Company (EMI), British Electric Transformers and Fairey Aviation. Thus, by 1931 the population had increased to 10,000 and it continued to increase thereafter. At its peak EMI alone employed some 16,000 people.

The rapid expansion of industry in the early 1900s was followed in the 1970s by a catastrophic decline, so that by 2013 all but one of the large factories had closed, and even this is scheduled for closure in the near future. By using old photographs accompanied by their present-day counterparts this book sets out to record the changes that have occurred in Hayes over the last 100 years.

Philip Sherwood
Harlington, 2013

# Acknowledgements

Most of the old photographs in the book are taken from the photographic collection of the Hayes & Harlington Local History Society. This collection was built up largely by the late Terry White, the society's chairman and curator from 1968 to 2012, to whose memory this book is dedicated. In many cases the more recent photographs have been taken specifically for inclusion in the book, but others come from the society's collection or from individual members. Information for the captions has been gleaned from other publications of the society and from members. Apologies are given to anybody whose material has been inadvertently used without acknowledgement.

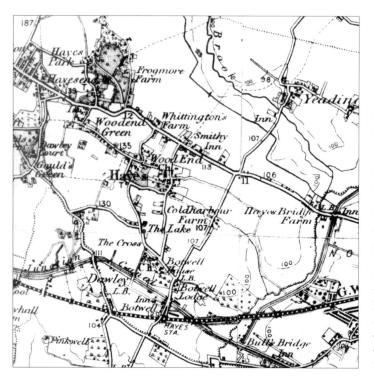

Hayes, c. 1900
Hayes village, then known as Hayes Town or Cotman Town, lies roughly in the centre of the large parish of Hayes. Around are the separate hamlets of Hayes End, Wood End, Wood End Green and, in the extreme south of the parish, Botwell, which has since usurped the name of Hayes Town. More remote to the north-east is the hamlet of Yeading where, according to a nineteenth-century chronicler, 'Dirt, darkness and ignorance reign supreme.'

# CHAPTER 1

# Churches

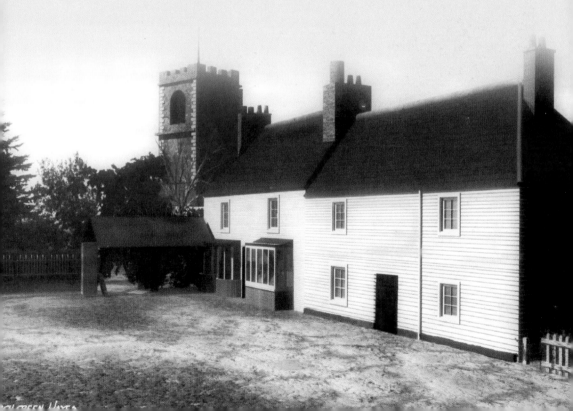

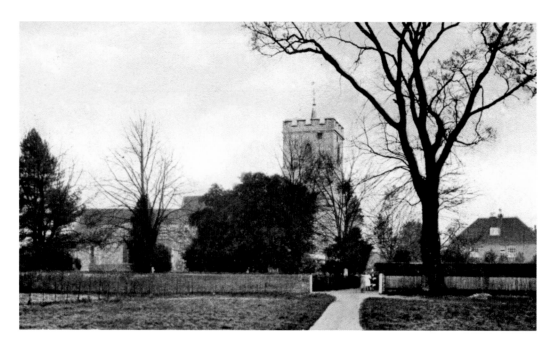

### St Mary's Church

St Mary's church, Hayes, from the west in the early 1900s. The building to the right of the church is Hayes Court, which dated from the eighteenth century (*see page 31*). Below, St Mary's church from the same viewpoint in 2012. Hayes Court was demolished in 1968 and its site is now used as a car park.

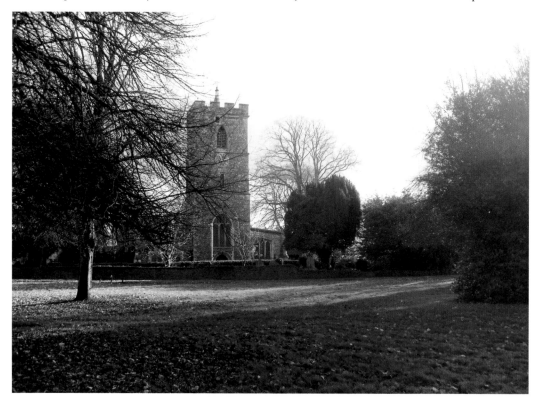

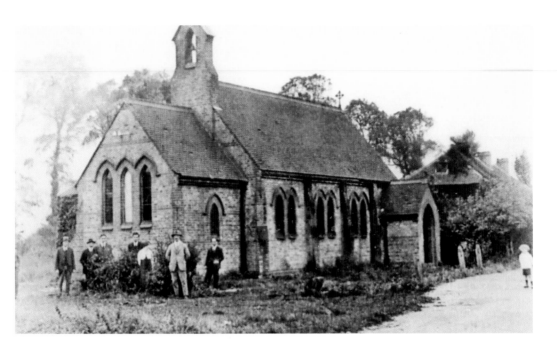

### The Mission Hall and St Anselm's Church

Botwell Mission Hall, Golden Crescent, *c.* 1900. On 14 March 1896, the second anniversary of the death of her husband Mr E. H. Shackle, Mrs Emily Shackle laid the foundation stone of a Mission Room to be erected in his memory. However, the rapid growth of Botwell soon made the hall inadequate for church worship, so steps were taken to erect a church on a site in Station Road to be called St Anselm's. In 1932 Middlesex County Council bought the Mission Hall, which was then extended to become Hayes Library (*see page 29*). Below, St Anselm's church, Station Road, in 2013. Initially a temporary corrugated-iron building was opened in 1913 as a replacement to the Mission Hall. This was replaced in 1929 by the present brick building. It is in fact quite a handsome building both inside and out but is so hemmed-in that it is difficult to appreciate it fully.

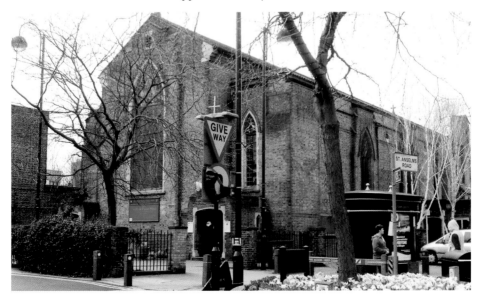

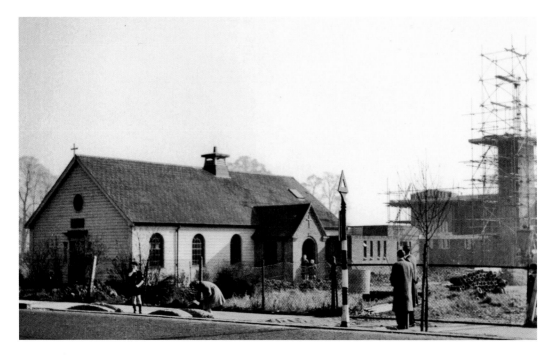

### St Edmund's Church

St Edmund's (Anglican) church, Yeading Lane, 1961. The expanding population of Hayes in the early twentieth century led first of all to the creation of the separate parish of St Anselm at Botwell. Other sub-parishes were also formed, including that of St Edmund at Yeading in 1932. The first church, which was little more than a shed, was replaced in 1933 with the building seen here. The above photograph shows the new church being built to the right and behind the 1933 church. Below, St Edmund's, Yeading Lane, in 2012. The present church was consecrated by the Bishop of Kensington on 1 July 1961.

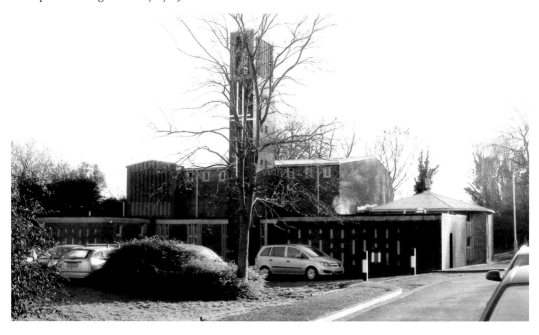

## Botwell House

Botwell House, Botwell Lane, *c.* 1910. This early nineteenth-century house, which still exists, was the home of Edward Neild Shackle, who was one of the principal landowners in Hayes. He sold it in 1912 to a Roman Catholic community recently established in Hayes. They converted the white single-storey building seen on the side of the house to a chapel. The growth in the Catholic community by 1920 necessitated an extension to the rear of the chapel, and then a large addition at the side was made to accommodate up to 600 people. This 'intermediate' church, as it was called, was superseded by an entirely new church nearby with a tall campanile, which was consecrated in 1962. Below, Hayes Catholic church, Botwell Lane, 2012. Botwell House, which can be seen to the left, is still recognisable from the previous photograph.

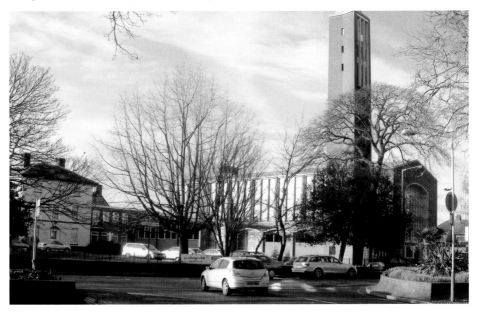

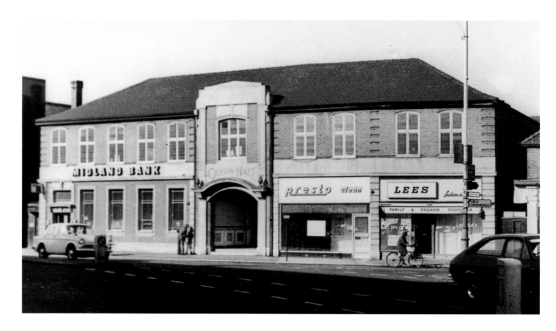

### Hayes Methodist Church

The Queen's Hall Methodist church, Station Road, *c.* 1960. Hayes Methodist church began life in Station Road in 1907. It was registered at that address in 1927. In 1930 the registered name was changed to Queen's Hall Methodist church, Station Road. In 1973 Queen's Hall closed and work began on a new church, which opened in September 1977, and was renamed Hayes Methodist church. Below, Hayes Methodist church, Station Road, in 2013. The new building occupies exactly the same site as its predecessor. The church is above the shops seen at ground level.

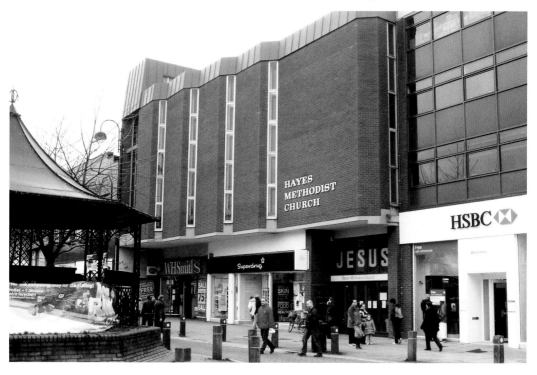

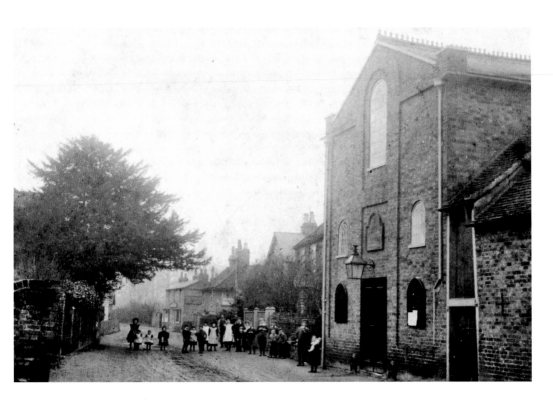

### Hayes Town Chapel

Hayes Town (Congregational) chapel, Church Road, viewed to the south in the early 1900s. The first building on this site opened as Hayes Town chapel in 1790. Due to internal dissension it was unoccupied from 1829 to 1842, and when it reopened the name was changed to Hayes Congregational church. It was demolished in 1959 shortly after the new church was opened. Below, Hayes Town chapel, Church Road, 2012. The new chapel stands about 100 yards south of its predecessor at the junction of Church Road with St Mary's Road. It was opened in 1955.

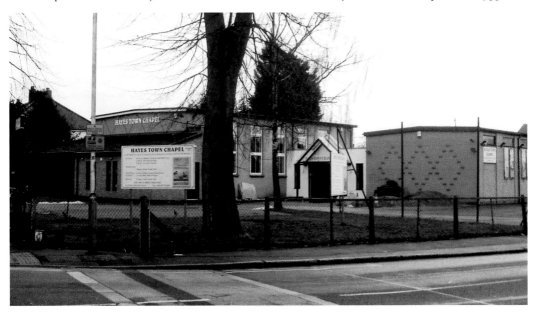

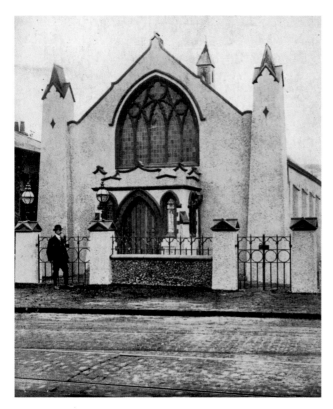

## Salem Baptist Church

Salem Baptist church, Uxbridge Road, Hayes End. The Baptists have had a presence in the locality since the 1700s, but this church opened for worship in 1908. The top photograph shows the church soon after it opened. The lower photograph shows the church and its surroundings in the 1970s and the view is still much the same today. The style of the building on the left suggests that it dates from the eighteenth century, and may have started life as a roadside forge.

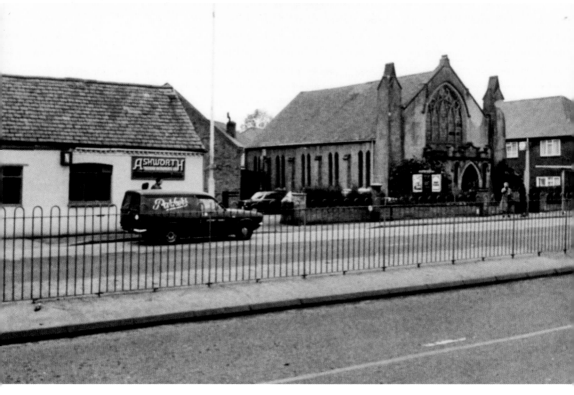

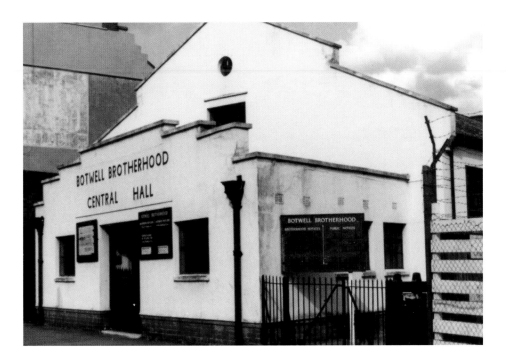

## The Botwell Brotherhood and Sisterhood

Above, Botwell Brotherhood Central Hall, Coldharbour Lane, 1982. The Botwell Brotherhood and Sisterhood, both organisations being non-sectarian and non-political Christian groups, were founded in 1913. At first the Brotherhood met in a cinema, and the Sisterhood in the Baptist Tabernacle Hall, both in Station Road. These sites were acquired by Woolworths, and the meetings moved to a hall built by the Brotherhood members, also in Station Road, next to the post office. In the early 1930s, this hall was sold for post office extensions and the hall in Coldharbour Lane, shown in the upper picture, was built in 1932. Below, Brotherhood Court, Coldharbour Lane, shortly after completion. The Brotherhood's Central Hall was demolished in 2002 and replaced with the block of flats, known as Brotherhood Court.

## CHAPTER 2

# Public Buildings

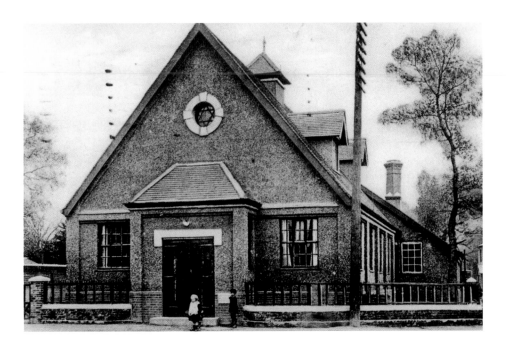

## Church Hall

Hayes Parish Rooms (St Mary's church hall), Church Road, in the early 1900s. The church hall was opened in the early 1900s at the corner of Church Road and Hemmen Lane. Below, the church hall in 2013. Superficially the hall looks much the same as when it was built, but it is in a sorry state of repair. It is still an attractive building in the centre of the Hayes Village Conservation Area and it continues to serve a useful function. Unfortunately it was built close up to both roads, with its doors opening directly onto the pavements, and there are no parking facilities. At the time of construction this was not a problem but now it severely limits its use. As a result consideration is being given to the construction of a new building in preference to its renovation.

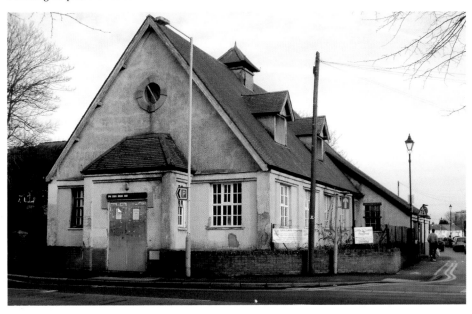

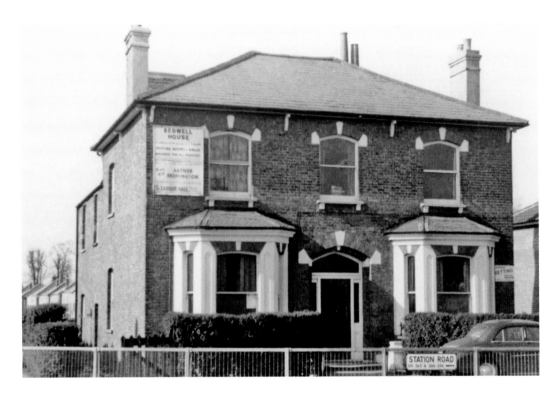

## Labour Party Offices

Labour Party constituency offices in Bedwell House, 1970. Strictly speaking this house is in Harlington. At the time of the photograph it was used by the Labour Party but it is now a veterinary surgery. It was built around 1880 for Charles Newman a local farmer. Below, former Labour Party constituency offices, Pump Lane, 2012. The Labour Party moved from Bedwell House to these premises in the 1970s but later transferred its offices once more to an inconspicuous building just out of view to the right. The building in the picture almost certainly started life as a 'tin tabernacle' belonging to a non-conformist sect.

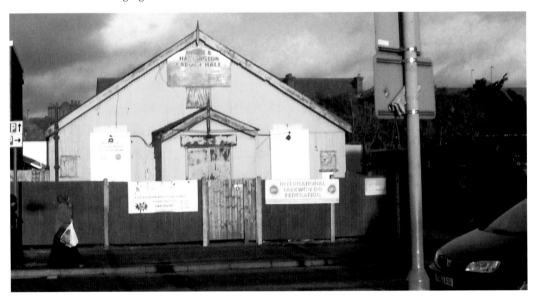

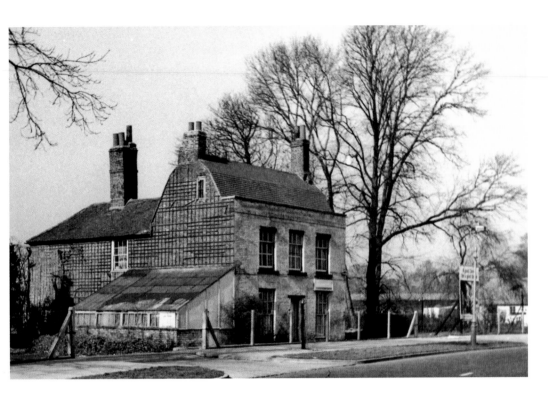

## Conservative Party Offices

Conservative Party constituency offices, Church Road, 1961. This house, known as 'Little Dawley', dated from 1787. This is around the time of the demolition of Dawley House in Dawley Road, but the connection between the two buildings, if any, is not known. It was demolished in 1973 and replaced with the new building shown below. Below, Conservative Party constituency offices, Church Road, 2012. The new building is undoubtedly better-suited for use as offices but the loss of its predecessor is a matter for regret.

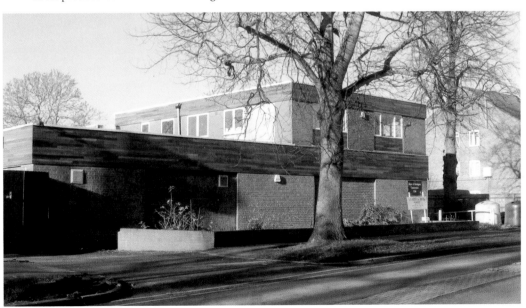

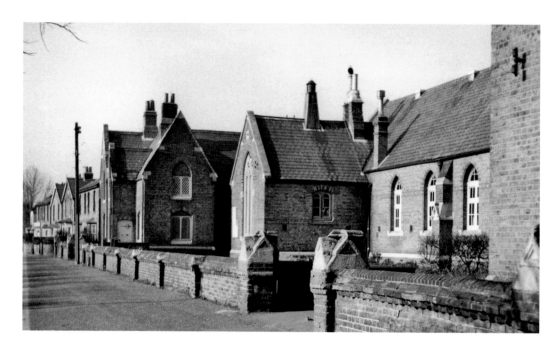

### Dr Triplett's School

Dr Triplett's School, Church Walk, *c.* 1950. The Church of England school was opened in 1863. It was named after Dr Thomas Triplett, as some of the money from his charitable fund was used to finance its construction. It closed in 1969 when a new school of the same name was opened nearby in Hemmen Lane. Below, Dr Triplett's school preparing for Hayes town fête, 12 June 1960 (the various modes of dress represent 1860, 1900, 1925 and 1960). The teachers are, from left to right: Mr Runnicles, Mrs Griffiths, Mr Saunders, Mr Pollard. Pupils: Ivan Higgins, ? Allum, Catherine Allum, David Jacklin, Christopher Sceeny, Linda Manley, -?-.

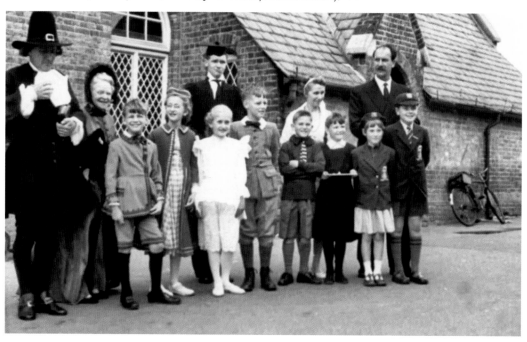

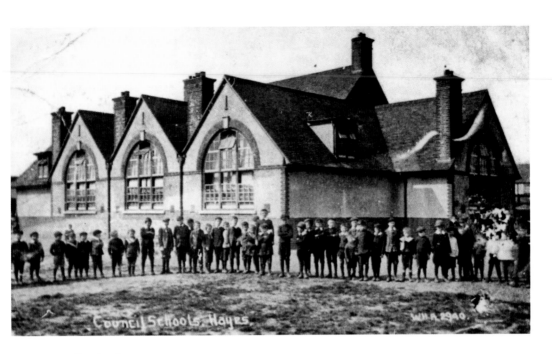

## Council Schools

Council School, Clayton Road, c. 1910. The Hayes Development Company, in developing the industrial site between the canal and the railway at Botwell, made provision for a school to serve the increased population, and a Council School was opened in 1906. The roll had increased from 134 to 732 in 1927, but new council and other housing estates had shifted the population centre further north. Consequently the school closed in 1931 and the pupils transferred to other schools nearby. The building was sold to EMI and survived for many years until it was demolished in 1962. Below, Townfield School, c. 1932. This view shows the girls' school on the left and the boys' school further away on the right. It was built as part of the construction of the Townfield council estate in anticipation of the increase in demand for school places to which this would give rise. It was opened officially on 18 February 1932. The school in Clayton Road was closed at about the same time, and many of their teaching staff were transferred to the new school. Townfield School closed in 1987 and the building, which has since been considerably enlarged, became the Hayes campus of Uxbridge College.

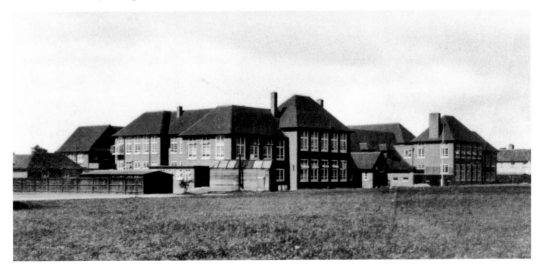

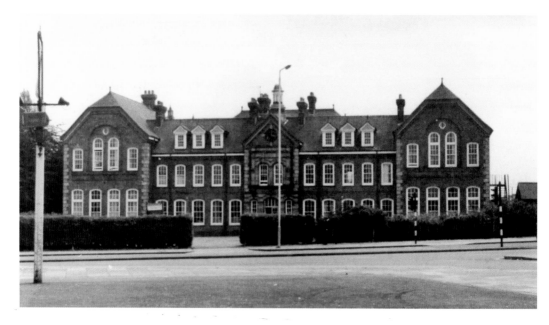

### St Christopher's School

St Christopher's School from the Uxbridge Road, c. 1960. This large building occupied the corner of the Uxbridge Road and Coldharbour Lane. It was opened in 1901 as the Hayes Certified Industrial School for Jewish Boys. The boys in question were juvenile delinquent Jewish boys and the school was among the first establishments of its kind to train boys for a skilled occupation after release. The school was eventually renamed St Christopher's School and retained that name until it was demolished to make way for the Lombardy Park Retail Centre. Below, the site of St Christopher's School, 2005. These shops, which form part of the Lombardy Retail Park, were built on the site of the school. The site is identical but the view is looking west whereas the previous view is to the south. This gives a better indication of the type of buildings that have replaced the school. The shops in the picture face Sainsbury's supermarket across a large car park; the Uxbridge Road is to the left with Coldharbour Lane behind the shops.

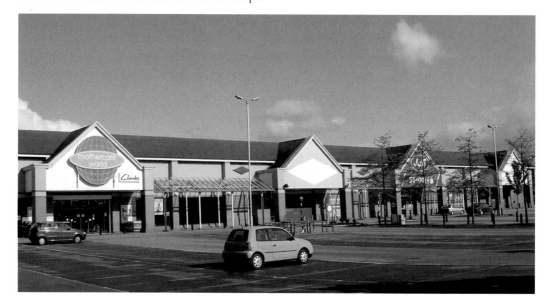

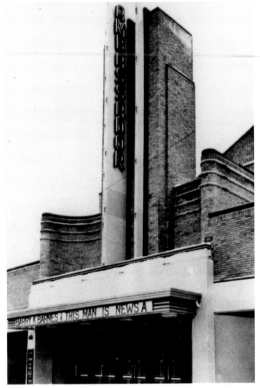

### The Ambassador

The Ambassador cinema, East Avenue, 1938. This photograph was taken during its opening week in December 1938. The title of the first film to be shown, *This Man is News*, is displayed on the canopy over the entrance. Below, the BT building, East Avenue, 2012.The Ambassador cinema was demolished in 1961 and replaced by the BT building. As seen from this angle it is not unattractive, and at the time it won a Civic Trust award. However, the concrete tower is a good (i.e. bad) example of 1960s brutalism and is a massive eyesore that looms over the shopping centre.

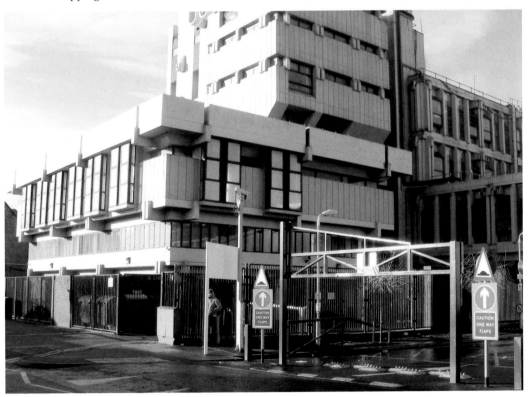

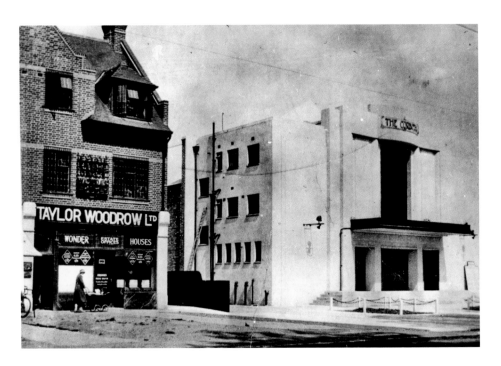

### The Corinth Cinema

The Corinth cinema, Uxbridge Road, shortly before opening. The cinema opened in August 1933 and closed on 8 July 1961. In the meantime it had changed its name to the Essoldo in 1949. It was demolished soon after closure and replaced with the buildings seen in the lower photograph. Below, Point West One, Uxbridge Road, 2012. The Corinth cinema was replaced by the row of single-storey shops and the multistorey office block seen here. The offices have since been converted to residential use and the exterior of the tower block covered with aluminium cladding, which has done little to improve its appearance.

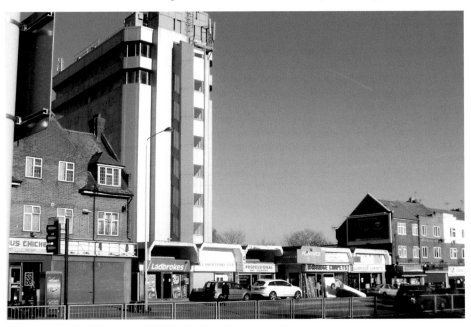

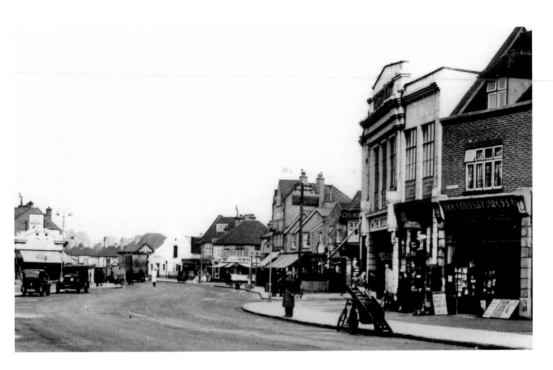

### Station Road

The Regent, Station Road, late 1940s. The cinema on the corner of Pump Lane opened in 1924. It became a theatre in 1948 and closed in 1953. It was demolished soon after and its site is now occupied by the NatWest bank. All the other buildings seen in the photograph survive, apart from the white building in the centre (the Botwell Brotherhood's hall – *see page 13*). Below, Station Road, 2013. The NatWest bank now occupies the site where the Regent cinema once stood.

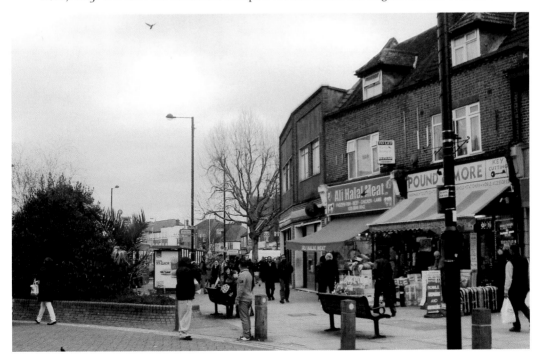

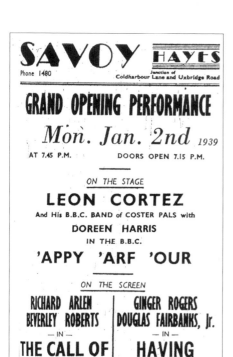

**SAVOY** HAYES

Phone 1480

Junction of
Coldharbour Lane and Uxbridge Road

## GRAND OPENING PERFORMANCE

### Mon. Jan. 2nd 1939

AT 7.45 P.M.        DOORS OPEN 7.15 P.M.

ON THE STAGE

## LEON CORTEZ

And His B.B.C. BAND of COSTER PALS with

### DOREEN HARRIS

IN THE B.B.C.

## 'APPY 'ARF 'OUR

ON THE SCREEN

| RICHARD ARLEN BEVERLEY ROBERTS — IN — | GINGER ROGERS DOUGLAS FAIRBANKS, Jr. — IN — |
| --- | --- |
| **THE CALL OF THE YUKON** (U) | **HAVING WONDERFUL TIME** (A) |

RESERVE YOUR SEAT
— IN ADVANCE FOR OPENING NIGHT —
AT NO EXTRA CHARGE.  PAY BOX OPEN 10 A.M. — 8 P.M.

The Savoy Cinema

A poster announcing the opening of the Savoy cinema on 2 January 1939. Below, the former Savoy cinema, Uxbridge Road. The Savoy was the last and by far the most impressive of the pre-war cinemas to be built in Hayes. In 1962, with the closure of the Essoldo cinema (formerly the Corinth – *see page 22*) further along the road, it changed its name to the Essoldo but was closed five years later on 3 September 1967. The building survives as a bingo hall. In 1972 a small cinema known as the Classic opened on a site adjacent to the Savoy, which is now occupied by the white building on the left of the photograph. This closed in 1986 so Hayes was left without a permanent cinema, although the Beck Theatre in Grange Road occasionally shows films.

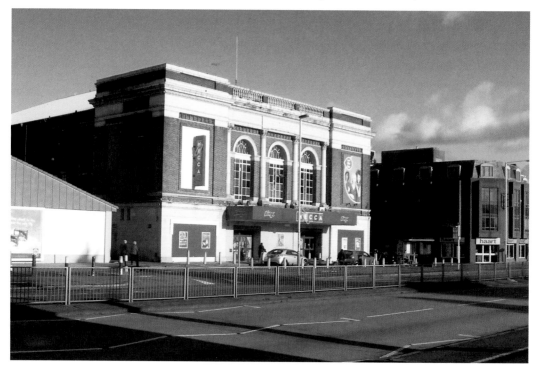

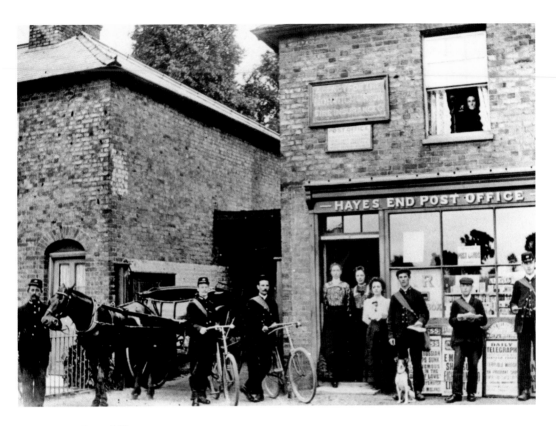

## Hayes Post Office

Hayes End post office, Uxbridge Road, early 1900s. Below, the former post office, Station Road, 2013. A Crown post office, complete with a sorting office at the rear, was opened in the early 1930s. In the 1980s the sorting office moved to new premises in Pump Lane and the post office closed in 2010 when its business was transferred to part of the shop of WHSmith. The building is now used as an NHS clinic.

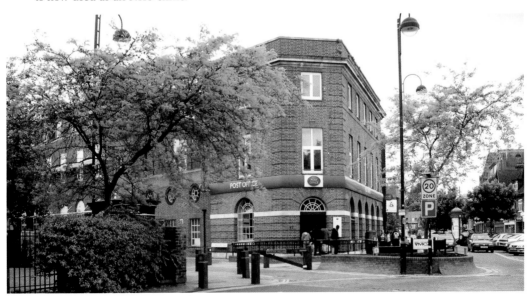

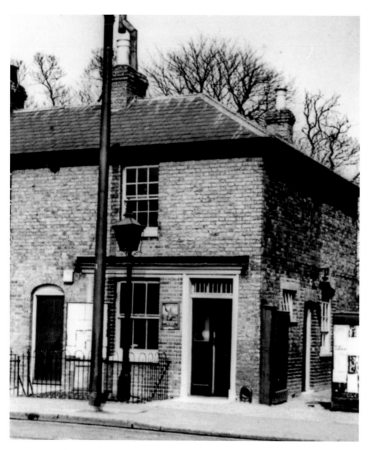

**Hayes Police Station**
Hayes' police station, Uxbridge Road, early 1900s. The police station moved from a site in Harlington Road into what began life as a cottage in 1870. The building had a charge room, two cells, stable accommodation and an inspector's quarters. Below, Hayes' police station, Uxbridge Road, in 2013. The new station was opened on the opposite side of the road in 1938.

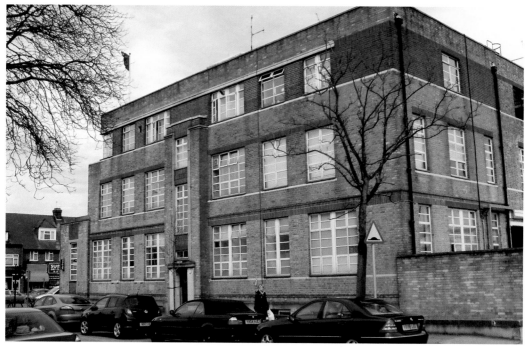

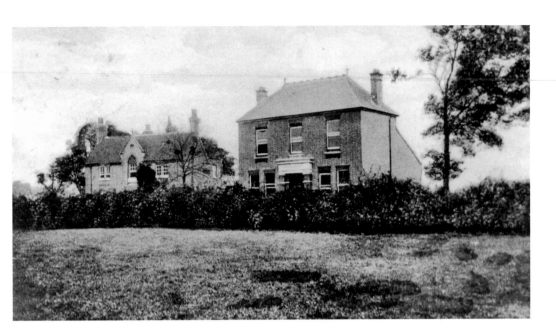

## Cottage Hospital

Cottage Hospital (*left*) and the council offices (*right*), Grange Road, early 1900s. A hospital, actually in a cottage in Hayes, was replaced in 1875 by a purpose-built hospital in Grange Road. Hayes Urban District Council opened offices nearby in 1905. The view showing both buildings was taken from Grassy Meadows, part of which is now the car park of the Beck Theatre. Below, Hayes Cottage Nursing Home, Grange Road, in 2012. In the 1920s the hospital needed to expand and therefore acquired the council offices after the council moved to Barra Hall, which became known as the town hall. The two buildings in Grange Road were joined in a major rebuilding in 1936 and a further extension took place in 1967. When the cottage hospital closed the buildings became a nursing home.

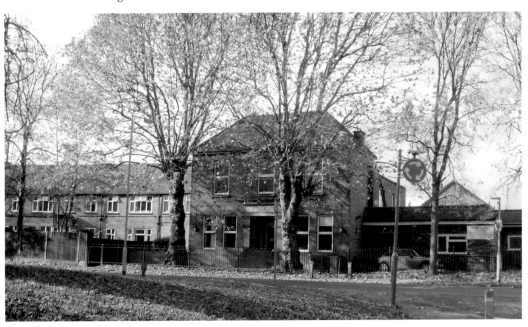

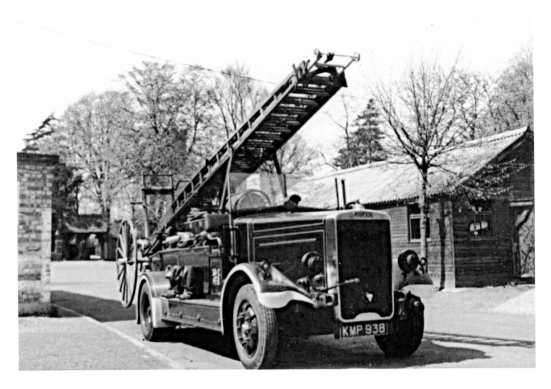

**Fire Station**

A fire engine outside Hayes' fire station, Church Green, 1930s. The original fire station was a series of wooden huts, some of which are now in use as an ambulance station. Below, Hayes' fire station, Shepiston Lane, 2006. The fire station was relocated to this site close to the M4 in Harlington in the 1960s.

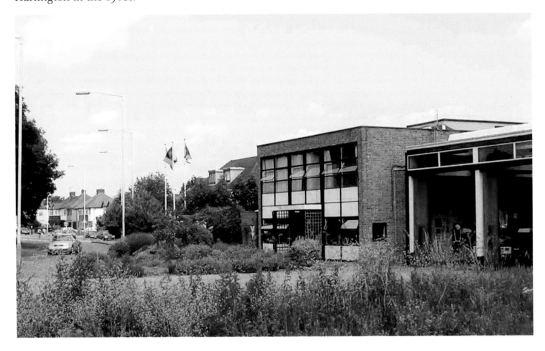

## Libraries

The former library, Golden Crescent, 2013. Botwell Mission Hall in Golden Crescent (*see page 7*) was acquired by Middlesex County Council in 1932 and enlarged to become Hayes Library, which was formally opened on 18 November 1933. It was closed in 2010 when the new library seen in the lower photograph was opened. On closure the building was adapted for residential accommodation but the external appearance was little altered. Below, Botwell Green Leisure Centre and Library, 2012. The new library forms part of this complex, which also incorporates a swimming pool and a gymnasium. As soon as it opened the old library and the former swimming pool in Central Avenue were closed. The old swimming pool has since been demolished.

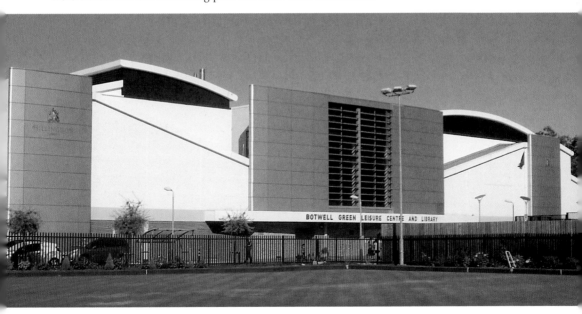

CHAPTER 3

# Private Houses

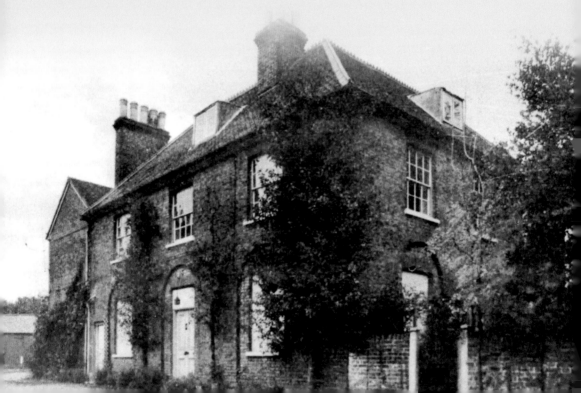

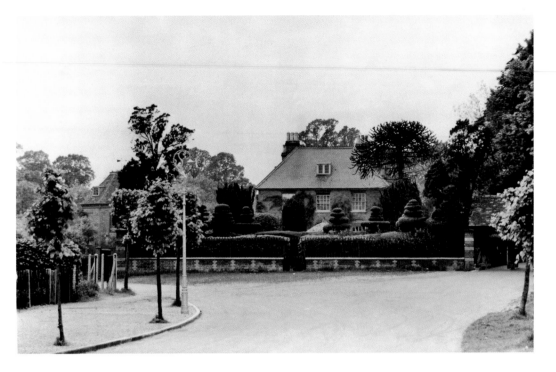

## Court Farm

The images on the previous page and above show views of Court Farm, Church Green, in the 1960s. The house adjoined St Mary's churchyard on its southern side. Variously known as Court Farm, Hayes Court or Court House, it dated from the late eighteenth century. Below, Church Green in 2013. The site of Court Farm, which was demolished in 1968, lies behind the trees on the left of the photograph. Rather surprisingly it has not been built upon and it serves as a car park for the church, which can just be seen through the trees on the right.

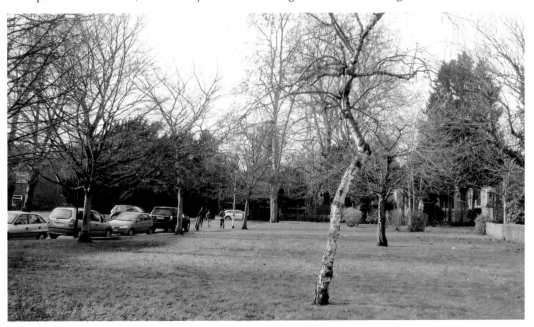

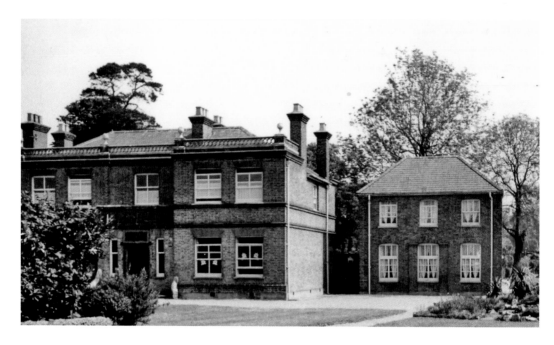

## Belle House

Belle House, Botwell Lane, shortly before demolition in 1962. This began life in the late eighteenth century as a private residence, but by 1841 it had become a boys' school run by Joseph Fleet, with thirty-seven pupils aged between seven and fourteen. It remained as a school until the 1880s, after which it was once again in private ownership. In the 1930s the house became a Roman Catholic convent; it was demolished in 1962 and replaced by the present convent. Below, St Mary's convent, Botwell Lane, 2013.

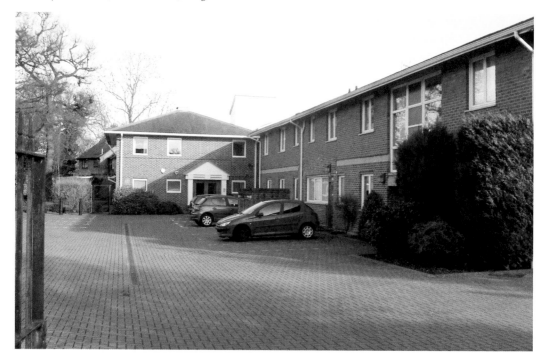

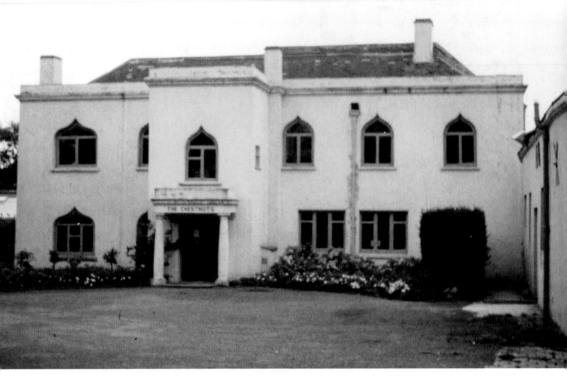

## The Chestnuts

The Chestnuts, Wood End, shortly before demolition. The house dated from the mid-eighteenth century and was later extended on the west side (to the right of the photograph). In accordance with the fashion of the time, the windows were later 'Gothicised' and ogee arches cut into the brickwork. Its most famous occupant was the composer Stephen Storace (1762–92). Its last owner was the local council which, true to form, failed to maintain it and it was demolished in 1963. Right, Stephen Storace, of Anglo-Italian parentage, was a well-known composer in his lifetime but, as with so many of his contemporaries, his compositions now suffer from the fact that they are completely overshadowed by those of Haydn and Mozart, the two musical giants not only of the time but of all time. He was an acquaintance of both, and his sister Nancy played the part of Susanna in the first production of the *Marriage of Figaro* in Vienna in 1786. He married in 1788 and came to live in Grove Cottage, later known as The Chestnuts.

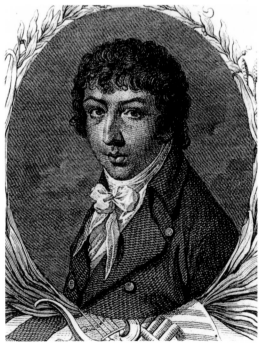

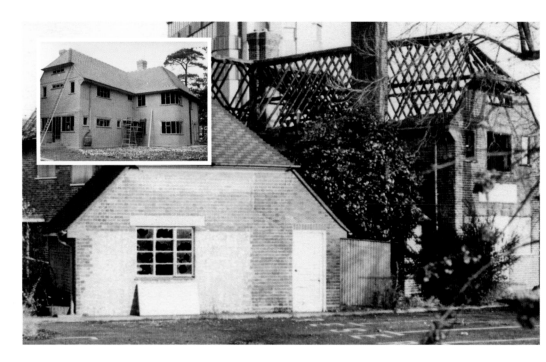

## The Grange

The Grange, Grange Road, in the course of construction in the early 1930s (*inset*) and under demolition in the 1980s (*above*). The house on the corner of Grange Road and the Uxbridge Road replaced an earlier house known as The Wrangle. It was used as a doctor's surgery and medical centre. It was damaged in a fire and subsequently demolished, and its site is now occupied by Uxbridge County Court (*see below*). The high-rise building in the background of the later photograph is Point West One (*see page 22*). Below, Uxbridge County Court, Grange Road, Hayes. Despite its name this courthouse is 3 miles away from Uxbridge. The original building still exists in Harefield Road, Uxbridge, but it was replaced with the one seen here, although the name was retained. It was built on the site of The Grange and opened on 8 February 2000.

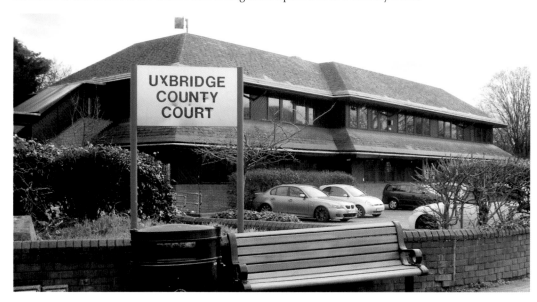

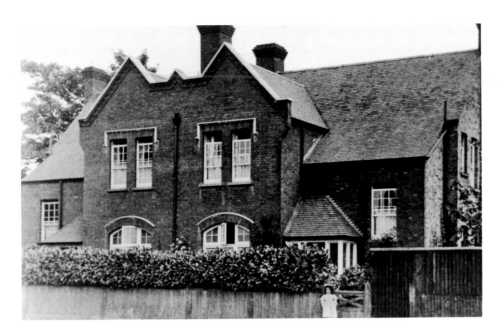

## The Hawthorns and the Briars

The Hawthorns (*left*) and The Briars (*right*), Church Road, *c.* 1912. These began life in 1904 as two separate houses, but from around 1910 to 1916 they were combined to form the rectory. They were then converted back again and the house on the left became a private school known as the Hawthorns High School for Boys. Between 1932 and 1933 Eric Blair, much better known by his pen name as the famous author George Orwell, was one of the teachers at the school. A plaque on the wall of the hotel now records this fact. Below, Michael Foot MP, one-time leader of the Labour Party, unveiling a plaque to record George Orwell's association with The Hawthorns on 21 April 1992. The plaque reads 'George Orwell (Eric Arthur Blair) 1903–50, lived and worked here as senior master of the former Hawthorn High School for Boys, April 1932 – July 1933'. As seen here, the plaque was originally on the left of the building as seen from Church Road, but it has since been relocated to a more prominent position on the right.

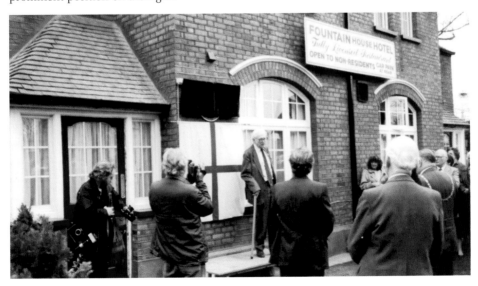

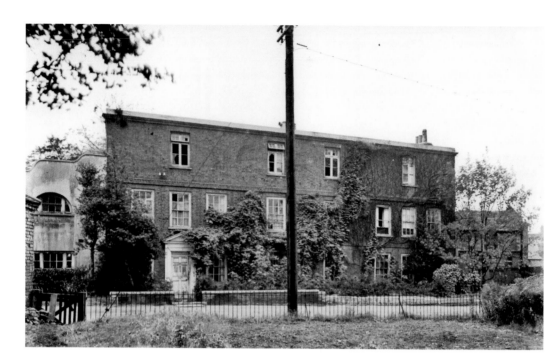

### Hayes End House

Hayes End House, Hayes End Road, shortly before demolition in 1946. This house, with pleasure grounds including a lake, dated from the eighteenth century. Between 1857 and 1865 it was used as a school for the education of the children of parents serving in India. It was later renamed The Shrubbery but had reverted to its original name by the time it was demolished. It stood on the west side of Hayes End Road a short distance away from the junction with the Uxbridge Road. Below, Hayes End Road west side, near the junction with the Uxbridge Road, 2013. This block of flats and an adjacent service station now occupy the site of Hayes End House.

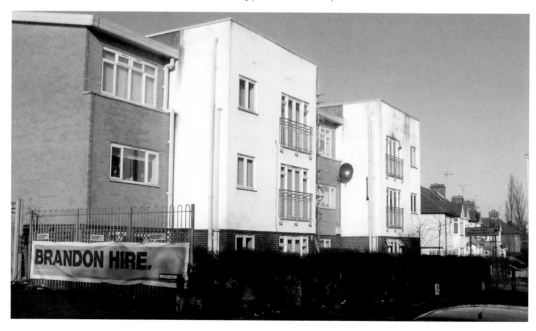

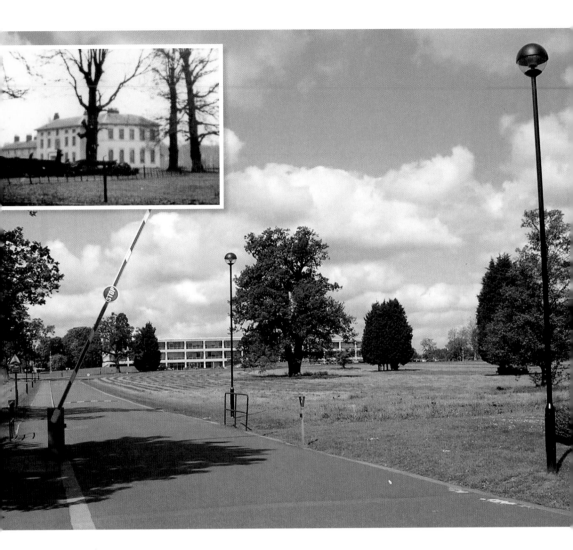

## Hayes Park

Inset, Hayes Park in the early 1900s. This mansion, belonging to Robert Willis Blencowe, was substantially rebuilt around 1820 as a two-storey dwelling with a central porticoed doorway. From around 1850, however, the house was used as a private mental home. It served this purpose until the break-up of the manorial estate in 1898, when the house was sold for use as a nursing home. In 1959 H. J. Heinz Ltd purchased Hayes Park for use as a research centre and offices. Three years later the house was demolished and the new offices, seen in the main photograph, were built on the site. Above can be seen Hayes Park in 2005. The new development is in keeping with the area and most of the parkland has been preserved.

## Lake House

Lake House, Botwell Lane, early 1900s. The house, which was owned by Thomas Shackle, stood on the east side of Botwell Lane opposite its junction with Botwell Common Road. It derived its name from an 'ornamental lake' (in reality a large pond). This lake was filled in 1954 and no traces of the lake or the house remain. Below, Lake Farm Country Park, Botwell Lane, 2013. The park is some 60 acres in extent and bounded by Botwell Lane, Botwell Common Road and Dawley Road. It derives its name from the lake in the grounds of Lake House. The land, which had belonged to the Shackle family, was purchased by EMI, which used the site for the testing of radar equipment for armoured vehicles. The company continued to use the site until the early 1990s, after which it attempted to sell the site for gravel extraction. This was successfully resisted and the site came into the ownership of Hillingdon Council, which is currently planning to build a school on that part of the site, seen in the photograph.

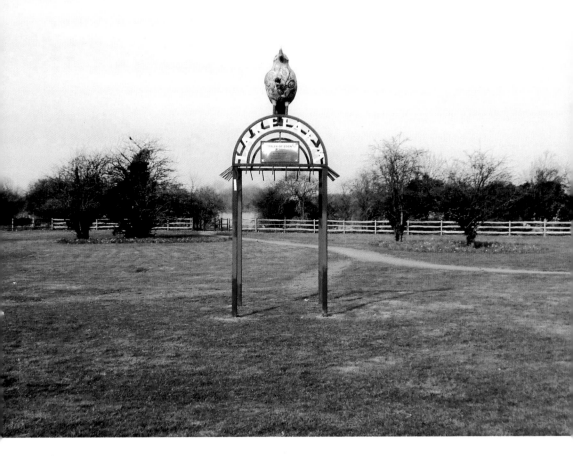

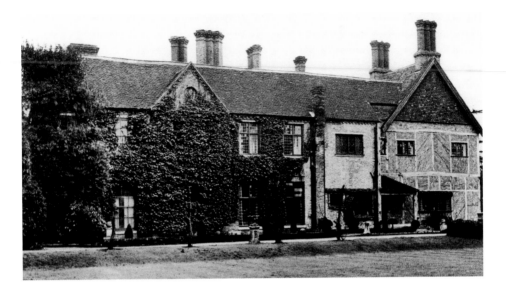

## Hayes Manor House

Hayes Manor House, Church Road, early 1930s. This building acquired this name despite the fact that there is no evidence a lord of the manor of Hayes was ever in residence. It dated from the seventeenth century, but was extensively altered in the 1860s to become the home of the rector of Hayes. In the 1930s the house was used as a remand home for boys. When the greater part was burned down in a fire, all that remained was that part on the extreme right of the picture. Below, Hayes Manor House in 2004. The surviving wing of the house is instantly recognisable from the previous photograph. It is now in the centre of a small housing estate.

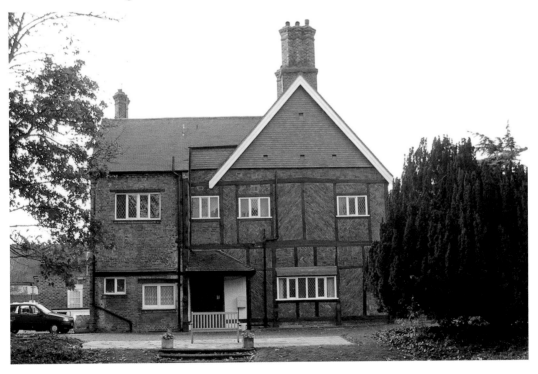

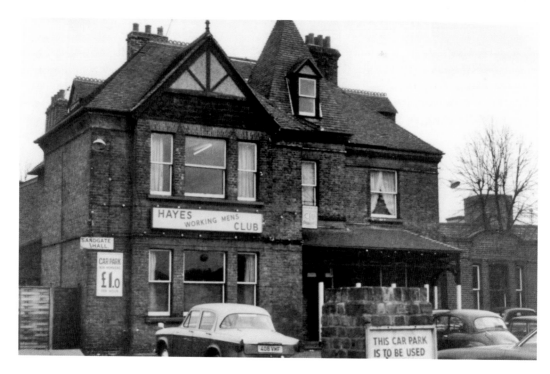

## Sandgate Hall

Sandgate Hall, Station Road, 1960s. This began life in the late nineteenth century as a private residence of a member of the Shackle family, standing in its own grounds. However, at the time of the photograph it was the headquarters of the Hayes Working Men's Club, which had bought the house in 1918. The club later moved to new premises in Pump Lane; the building was demolished and shops built on its site. Below, Argos and Aquis House, Station Road, 2013, built on the site of Sandgate Hall.

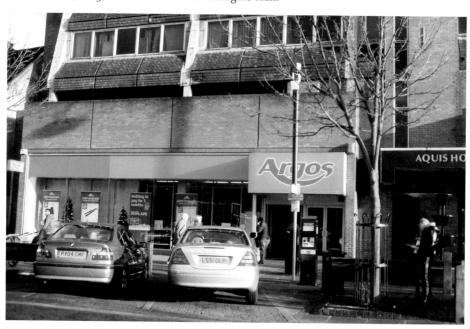

### Wood End House

Wood End House shortly before demolition. The house began life as a private residence surrounded by a large ornamental garden. A walled vegetable and fruit garden was attached to the gardens on the west side of the site. In the early part of the 1900s the house and grounds became a private nursing home. When the home closed, the house and grounds came into the ownership of the of the local council, which used the site as the headquarters of the Parks Department until 1960. As in the case of the Chestnuts (*see page 33*) the council failed to maintain the building, which was consequently condemned as unsafe and demolished. Below, Norman Leddy Memorial Gardens. Wood End House was demolished in 1961 and the site was developed into the Hayes Botanic Gardens. The walled vegetable and fruit garden became the council's tree and shrub nursery, although it was lost to the site in 1975 as part of a road-improvement scheme. The gardens were developed over the years and in 1993 were renamed the Norman Leddy Memorial Gardens in memory of the assistant director of parks who had done much to raise the standard of the gardens.

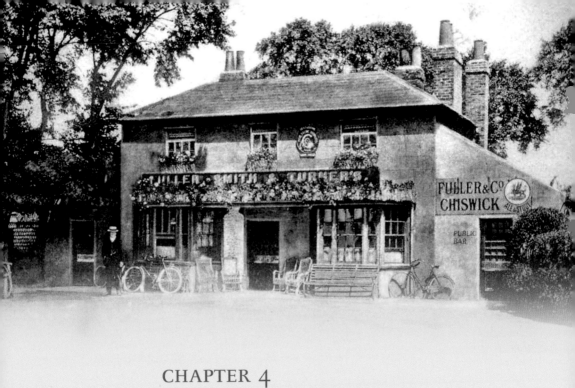

CHAPTER 4

# Public Houses

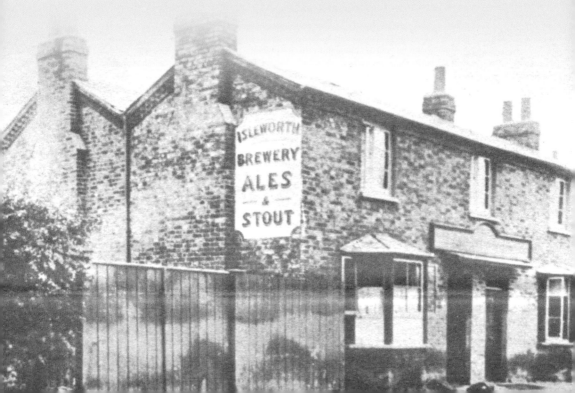

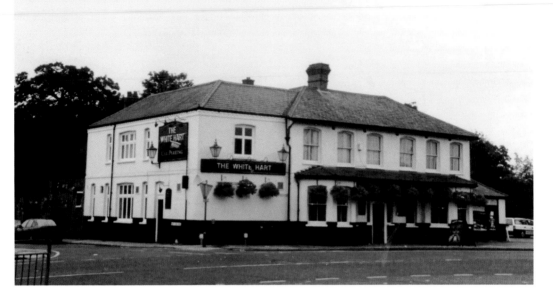

## The White Hart

The White Hart, Uxbridge Road, 1985. An earlier photograph of the pub, which stood at the junction of Hayes End Road with the Uxbridge Road, can be seen at the top of the previous page. This pub was demolished and replaced with the one seen here, which it in turn was demolished in 2003 to be replaced with the block of flats seen below. Below, White Hart Court, Uxbridge Road, 2013.

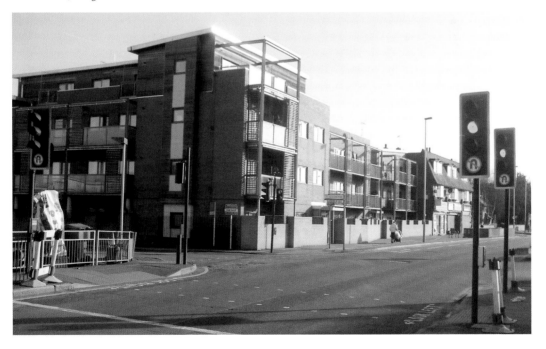

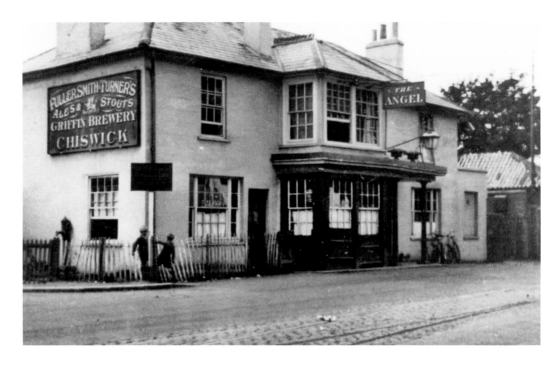

### The Angel

The Angel, Uxbridge Road, 1924. The building seen here dated from the eighteenth century and, unlike the other inns on the Uxbridge Road in Hayes, it stood on the south side of the road almost opposite the White Hart. It was demolished in 1926 and replaced with the building seen in the lower photograph. Below, the Angel in 2005. The view is to the east. On the opposite side of the road White Hart Court (*see page 43*) can be seen in the course of construction.

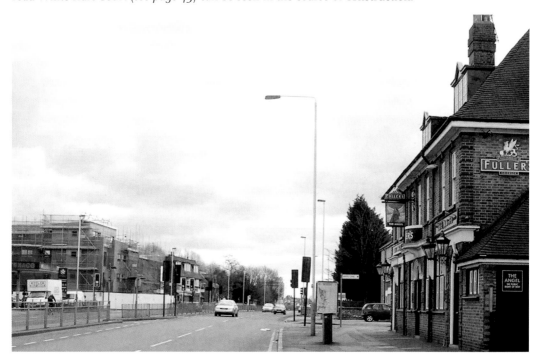

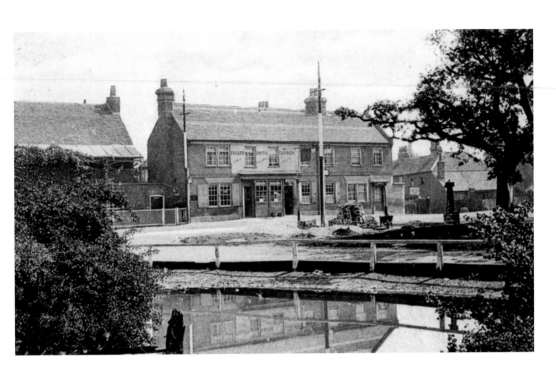

### The Adam & Eve

The Adam & Eve, Uxbridge Road, *c.* 1904. The view is from Church Road looking north across the Uxbridge Road. This had been a coaching inn with extensive facilities for the coaches, horses, etc., in the yard behind. The house to the left of the inn was known as Oakdene, the home of Marion Cunningham, a local suffragette. Below, the same view in 2005. The old inn was replaced with the new building in 1937. Oakdene on the left survives although it has now been split into two shops.

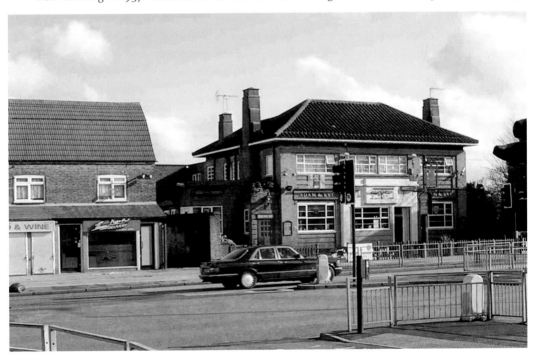

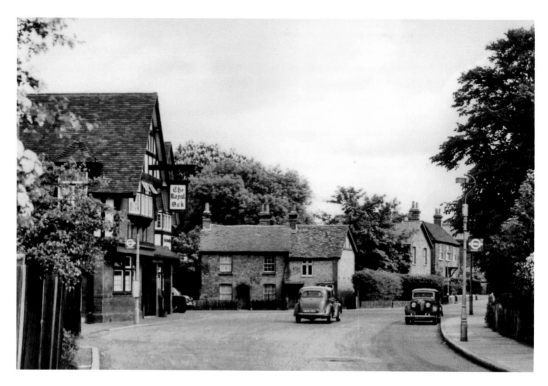

Church Road

The Royal Oak, Church Road, in the 1950s. The view is to the north at the junction of Freeman's Lane with Church Road. The pub seen here replaced an earlier building seen in the lower image on page 42. It was demolished in 2004 and replaced with the block of flats seen below. Below, Church Road at the junction with Freeman's Lane in 2012.

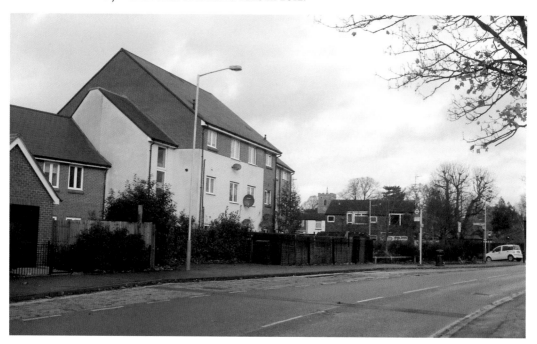

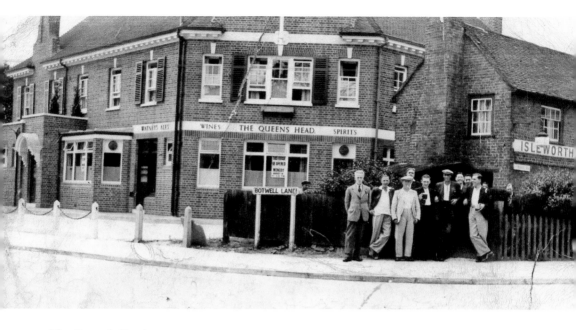

## The Queen's Head

The Queen's Head, Botwell Lane, 1939. The original Queen's Head was an eighteenth-century beerhouse that stood at the junction of Botwell Lane and Wood End Green Road. The inn was demolished in 1939 and replaced with one of the same name. This photograph was taken on the day that the new pub was opened. Some of the clientele can be seen standing outside, and the poster in the window announces the opening date. On the opening of the new pub, the old one, seen on the right, was demolished. Below, the Grange, Botwell Lane, 2006. The new Queen's Head was renamed the Grange in 1986, and changed its name once more to Tommy Flynn's in 2011. Apart from the name changes the exterior of the building has not been changed since it was built.

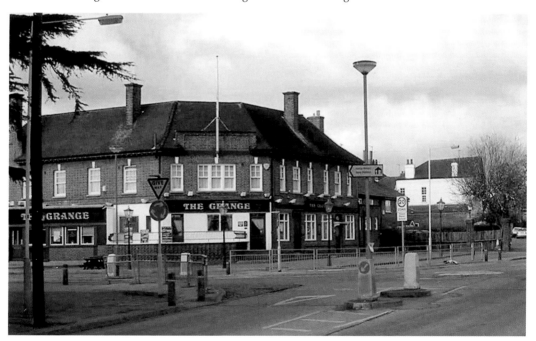

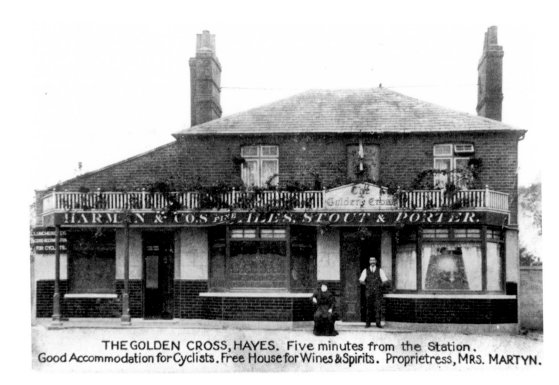

THE GOLDEN CROSS, HAYES. Five minutes from the Station.
Good Accommodation for Cyclists. Free House for Wines & Spirits. Proprietress, MRS. MARTYN.

**The Golden Cross**

The Golden Cross, Botwell Lane, *c.* 1912. This typical mid-nineteenth-century pub was demolished in the 1930s and replaced with a pub of the same name. The licensee in 1912 was Mrs Mostyn, who was the widow of former licensee Frederick Mostyn. The two people in the photograph are probably Mr and Mrs Mostyn. Below, the former Golden Cross, Botwell Lane, 2013. Like many others, this closed as a public house and is now a restaurant; there are plans to build a small hotel on the site. Before its closure as a pub it had been extensively modified and extended.

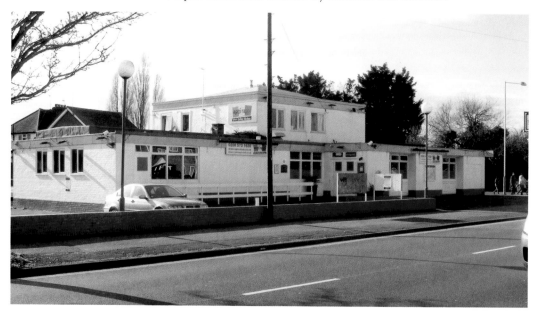

## The Blue Anchor

The Blue Anchor, Printing House Lane, *c*. 1950. The large building in the background is the Central Research Laboratories of EMI. The bridge over the Grand Union Canal can be seen between the two buildings. Below, the Blue Anchor in 2013. The public house depended on the nearby EMI factories for most of its trade, and with their closure, the absence of nearby houses and restricted parking facilities, it has ceased to be viable. It now stands forlornly awaiting inevitable demolition.

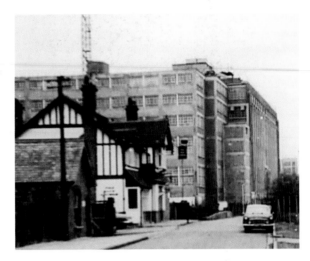

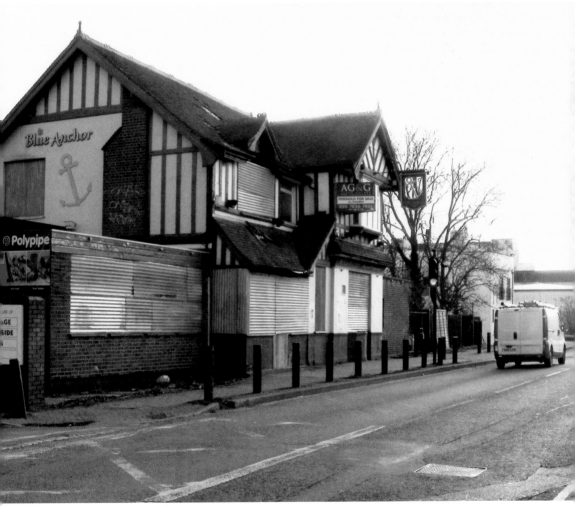

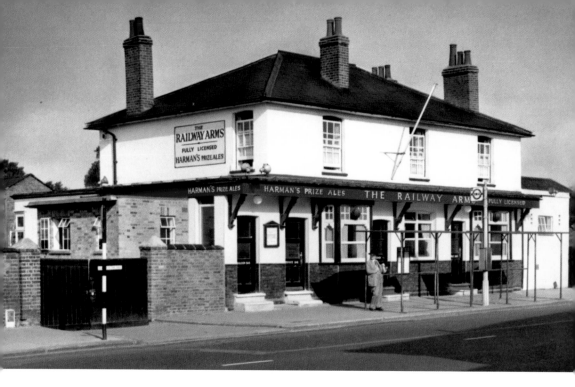

## The Railway Arms

The Railway Arms, Station Road, shortly before demolition. This nineteenth-century pub stood near the junction of Station Road with Clayton Road, close to the bridge over the canal. On demolition it was replaced with the tower block seen in the lower photograph, the ground floor of which was a pub known as The Tumbler. Below, the YMCA building, Station Road, 2013. There is no longer a pub on the site and the building is now occupied by West London YMCA.

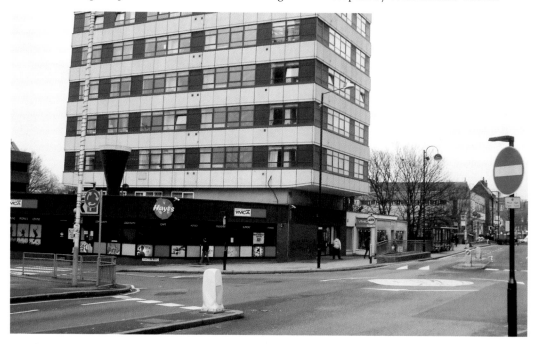

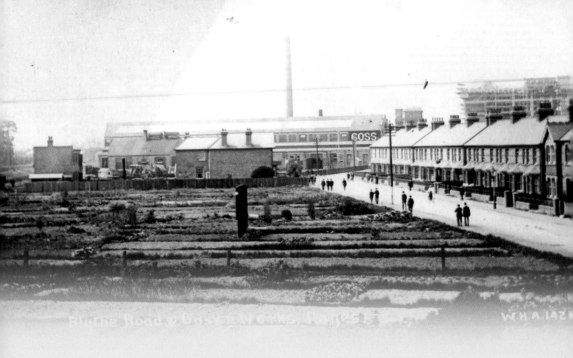

# CHAPTER 5

# Street Scenes

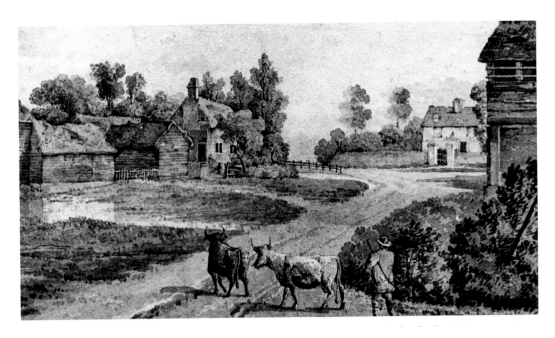

## Botwell Lane

Botwell in 1821. This view is from a painting by an artist called Hedges about whom little is known. It shows the junction of the present Station Road with Botwell Lane to the left and Coldharbour Lane to the right. The cows would be standing approximately where the bandstand is now. Old maps show that all the buildings pictured here had gone by 1866, with the exception of the barn at the right of the picture. A new house, called Redleaf, was built by 1866 by the Shackle family near the site of the house at the right. It survived until it was replaced by shops in the early 1930s. Below, Station Road in 2005. The view is broadly from the same aspect as in the previous illustration, with Botwell Lane leading off to the left and Coldharbour Lane to the right. The photograph was taken soon after the road had been pedestrianised but before it had been partially reopened to traffic.

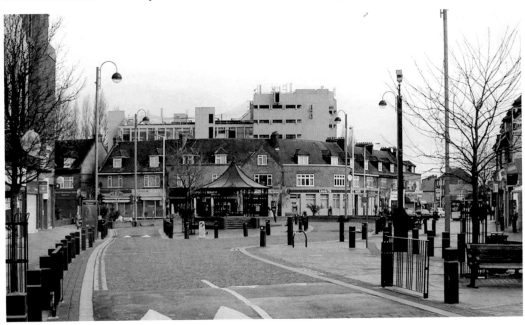

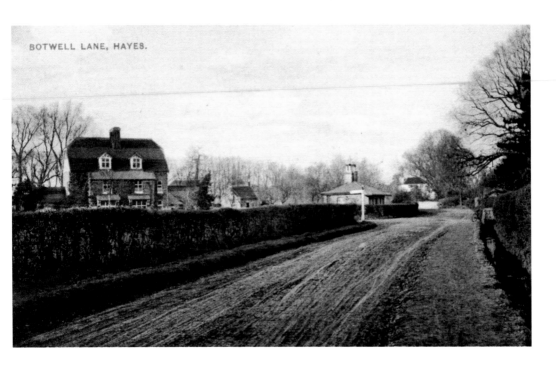

BOTWELL LANE, HAYES.

## Botwell Lane

Botwell Lane looking north, just south of the junction with Botwell Common Road, in the early 1900s. Below, the same scene in 2013. In both pictures the large white house known as Whitehall can be seen to the right in the distance. This is the only building to remain that confirms that both views were taken from the same vantage point.

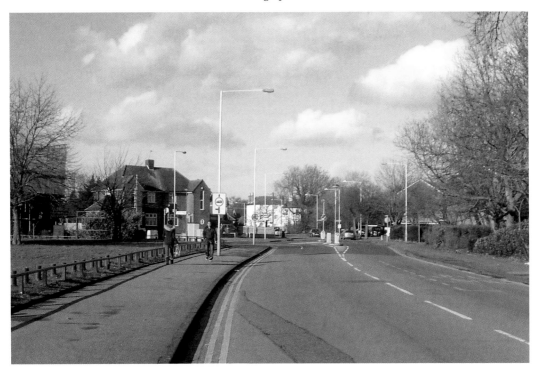

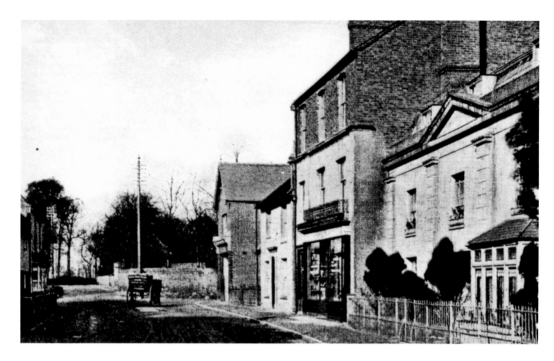

## Hayes Village

The village street in the early 1900s, looking north. On the right the nearest building is Wistowe House, a Grade II listed building dating from the eighteenth century, then Barden House (three storeys), Little Barden House, and the projecting front of the shop on the corner of Hemmen Lane, all of which date from the nineteenth century and are locally listed. On the left is the Old Crown (the hanging sign of which can just be seen). Below, the view in 2004, still recognisably the same, although Wistowe House has lost its pediment, and with the addition of the Church Hall on the corner of Hemmen Lane plus the early twentieth-century cottages on the left.

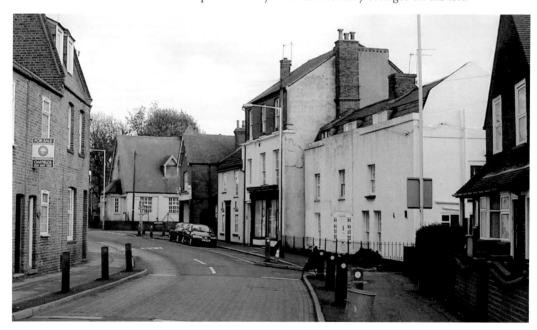

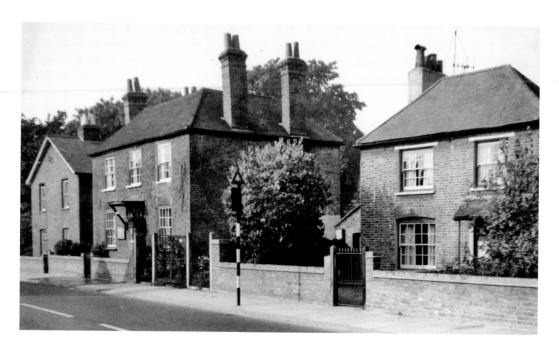

## Hayes Village Centre

Hayes village centre looking south with Craven House and Chapel House (Cobweb Cottage), *c.* 1960. These late eighteenth-century cottages formed an integral part of the Hayes Village Conservation Area. Chapel House had been part of Hayes Town chapel but it survived the demolition of the chapel. Before its demolition it had been defaced by stone cladding but Hillingdon Council declined to take any action on the disfigurement and later did nothing to stop its demolition. Below, Church Road in 2013. The two cottages seen in the previous photograph were in the heart of the Hayes Village Conservation Area but, despite public protests, Hillingdon Council granted permission for the demolition of Chapel House in 1997, and its replacement, a modern house, is inoffensive in itself but entirely out of character with its surroundings. The council's inaction was a sad indictment of its attitude to conservation at that time and led to the mass resignation of the Hayes Conservation Area Advisory Panel.

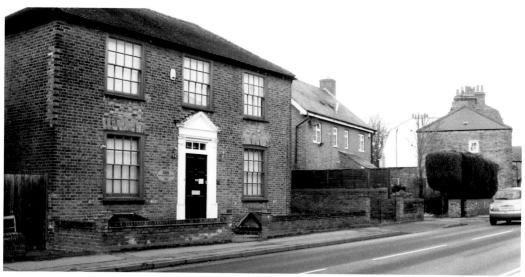

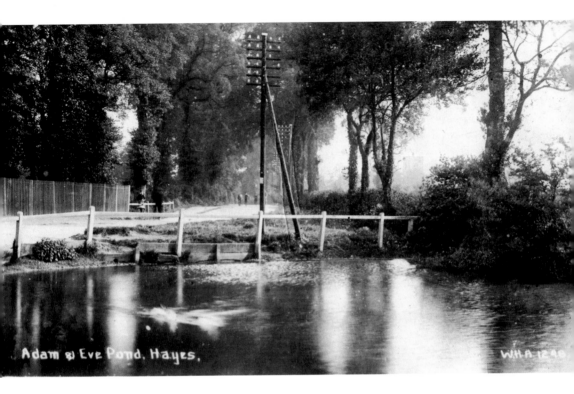

Adam & Eve Pond, Hayes. W.H.A. 1246

### Church Road

Church Road looking south from the Uxbridge Road in the early 1900s. The road junction is immediately opposite the Adam & Eve, and at the time the road was known as Adam & Eve Lane. The pond in the foreground also derived its name from the public house. Below, Church Road looking south in 2012.

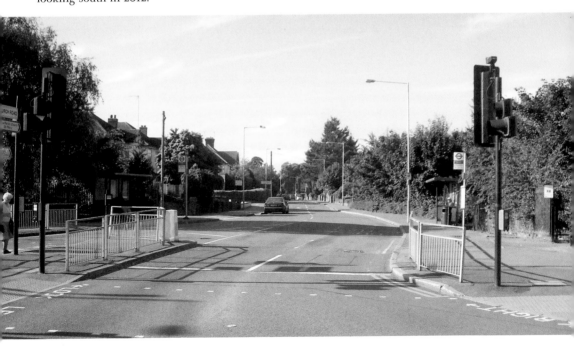

## Dawley Road

Dawley Road, *c.* 1970. From Bourne's Bridge almost to Gould's Green, Dawley Wall runs along the west side of the road. It was built in the eighteenth century, during the time that the Earl of Uxbridge was the occupant of Dawley House. Popular legend has it that he built it to keep out the plague, but it is most unlikely that he was so naïve as to believe that it could. It is far more likely that it was built to keep out trespassers. Below, Dawley Road in 1991. Much of the area once occupied by the grounds of Dawley House is now part of Stockley Park. The existence of Dawley Wall offered a clear boundary between the park and the road, and as such much of it was restored as part of the development of Stockley Park, using bricks of the same type as those used originally in the eighteenth century.

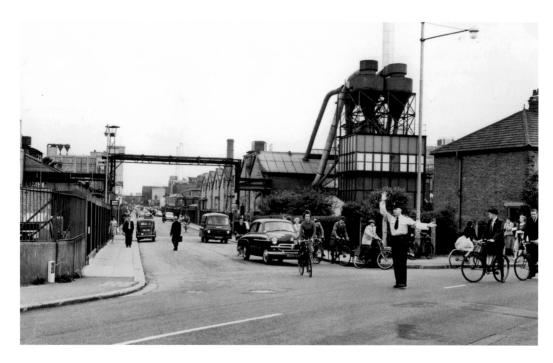

## Blyth Road Junction

The junction of Blyth Road with Dawley Road, *c.* 1960. The view is to the east, with workers leaving the EMI factories that can be seen on either side of the road. In 1960 the EMI workforce in Hayes numbered some 16,000, and at the end of the day an enormous number of workers disgorged onto the local roads. This explains the presence of the policeman on point duty, but the relatively light traffic indicates that the photograph was taken just before or just after the main exodus. Below, the same view in 2005. The building centre-left in the middle distance can be seen in both photographs. It dates from the early 1900s, was the first multistorey factory to be built and remains in industrial use. Some of the other EMI factory buildings have been refurbished and are occupied, but many have either been demolished or are standing derelict. The two photographs epitomise the decline of industry in Hayes.

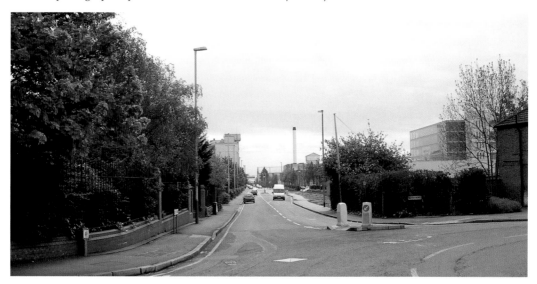

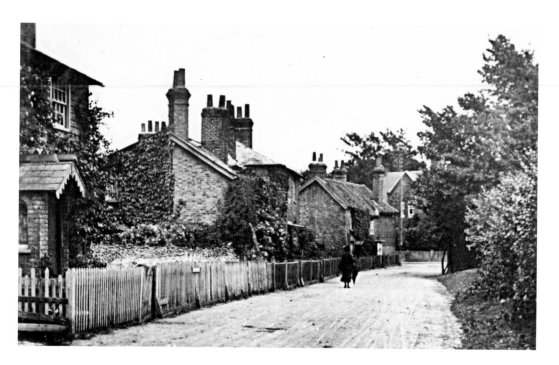

### Freeman's Lane

Freeman's Lane in the early 1900s looking east, with The Hawthorns (now the Fountain House Hotel) at the junction of the lane with Church Road. The lane takes its name from the Revd John Neville Freeman, a much loved vicar of Hayes between 1792 and 1843. Most of the cottages were of brick and weather-boarded construction, and dated from the eighteenth century. The nearest cottage on the left was No. 18, where a Mrs Gibbons murdered her husband in 1844. She was tried and sentenced to death but the sentence was later commuted. On her eventual release she returned to live in Hayes. Below, Freeman's Lane in 2005. The cottages in the lane were replaced with some council developments in the early 1960s. The only building common to both photographs is what is now the Fountain House Hotel in the middle distance.

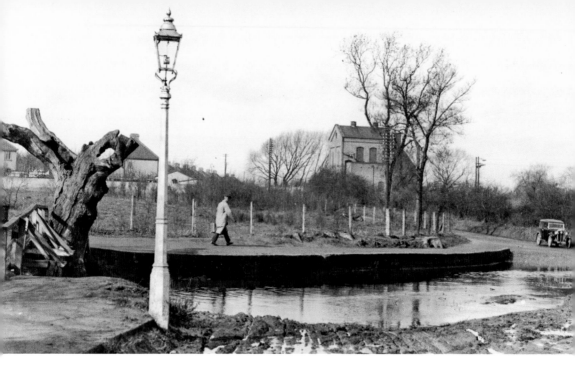

## North Hyde Road

North Hyde Road, looking west with the ford over the River Crane in 1935. It seems incredible that as late as 1935 a ford should have still existed in what is now a very busy road. The large building on the right was an electricity substation, although judging from the lamppost the road was lit by gas. Houses are just starting to appear on the other side of the road, which is now lined with houses on either side. Below, North Hyde Road, the bridge over the River Crane. The road was bridged soon after the previous photograph was taken. The absence of traffic shows that the photograph was taken early on a Sunday morning. Normally, because of the heavy traffic, it would be impossible to see the parapet of the bridge from this position.

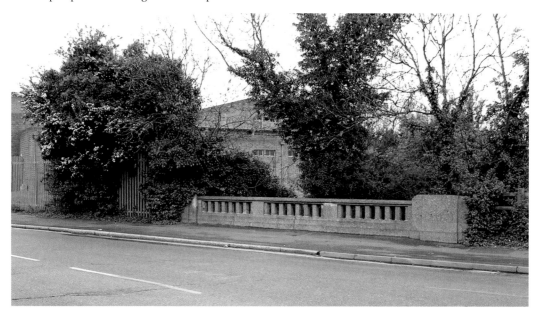

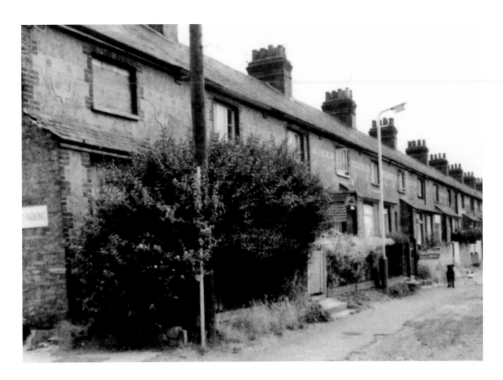

## Western View

Western View in the 1950s. Despite the name, this terrace of Victorian cottages faces due south! They were demolished in the 1960s and, together with the area behind, were replaced with the council housing development seen in the lower photograph. Below, Western View 2013. This is the view to be 'enjoyed' by the residents of High Point Village (*see page 70*).

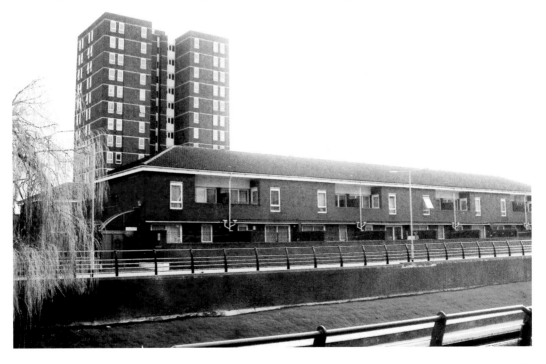

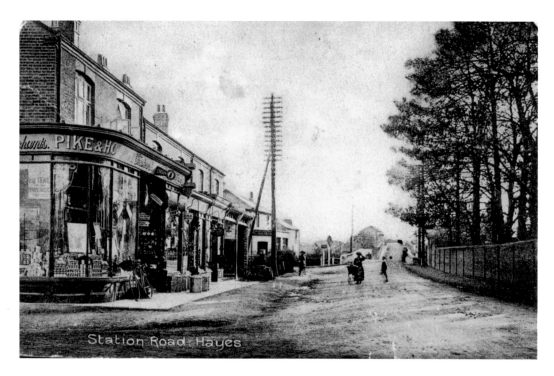

## Station Road

Station Road from the junction with Crown Close in the early 1900s. The view is to the south with the railway bridge in the middle distance. Below, Station Road from Crown Close junction in 2013. Most of the buildings seen on the left of the previous photograph survive, but the right-hand side has changed completely.

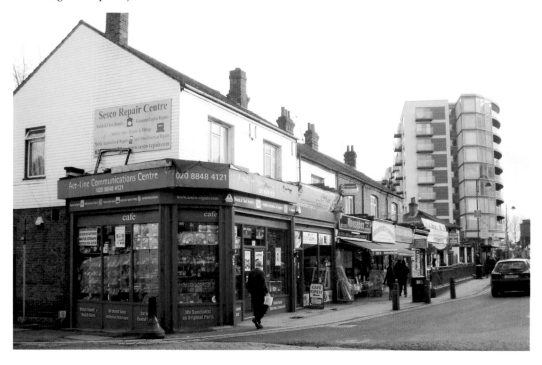

### Yeading Lane

Yeading Lane, early 1900s. The view is to the north, with the Industry public house on the left and the bridge over the Yeading Brook in the distance. Below, Yeading Lane in 2005. The view of the road has changed beyond all recognition, with only the name of the road providing a link with the past.

# CHAPTER 6

# Transport

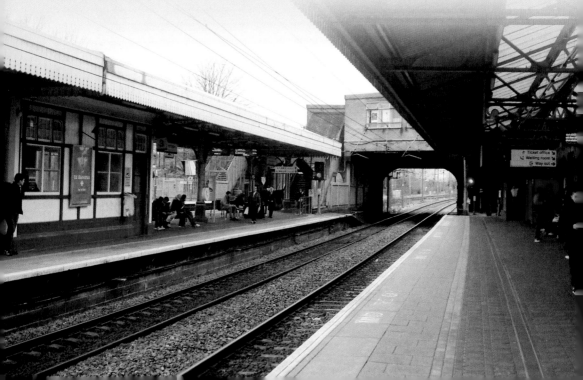

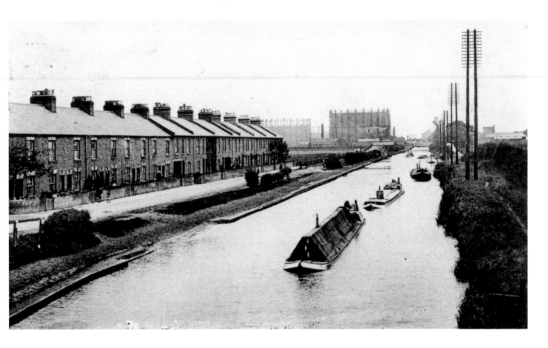

## Grand Junction Canal

The Paddington Arm of the Grand Junction Canal at Hayes Bridge, early 1900s. The view is to the south with Southall gasworks in the middle distance. The route of the canal from Uxbridge to Brentford was completed by 1798. A branch running from Bull's Bridge, Hayes, to Paddington Basin opened in 1801. The large number of barges that can be seen in the photograph is a reflection of the importance of the canal as a transport artery at that time. Below, Bull's Bridge, Hayes, 2012. The view was taken from the main route of the canal with the Paddington Arm branching off to the left. The bridge was built to take the towpath over the Paddington Arm. The signpost has three arms pointing respectively to Brentford (6 miles), Paddington (14 miles) and Birmingham (87 miles).

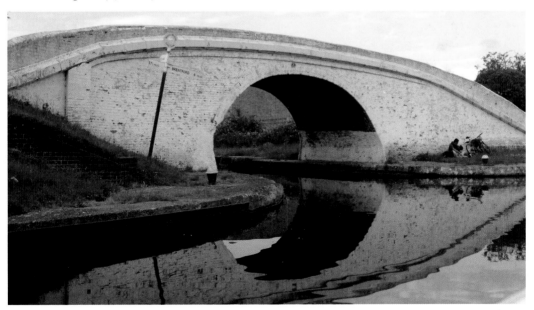

### Rigby Lane Bridge

Above, Rigby Lane Bridge over the canal. Below, the plaque on the Rigby Lane Bridge. The canal crossed several roads, all of which had to be bridged. The bridges, built of brick, were to a standard design such as that seen in the upper photograph. At the time of construction the only traffic on the roads was horse-drawn and the canal company could never have envisaged the immense growth in the weight of traffic that would occur 100 years later. Consequently, when it did occur the company had to put warning notices on the bridges carrying the minor roads over the canal, such as that seen in the lower photograph. In the case of the major roads, by the 1930s the original bridges had all been replaced.

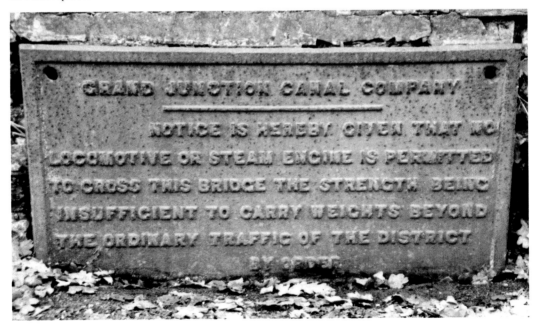

GRAND JUNCTION CANAL COMPANY

NOTICE IS HEREBY GIVEN THAT NO LOCOMOTIVE OR STEAM ENGINE IS PERMITTED TO CROSS THIS BRIDGE THE STRENGTH BEING INSUFFICIENT TO CARRY WEIGHTS BEYOND THE ORDINARY TRAFFIC OF THE DISTRICT BY ORDER

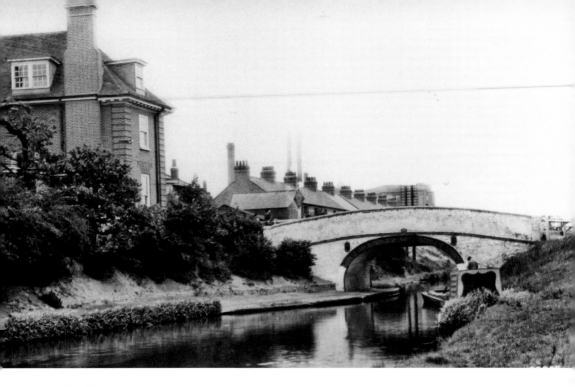

## Canal Bridge

Canal Bridge, Station Road, *c.* 1920. The view is to the east. On the left is the original Barclays Bank, which was demolished in the 1970s and replaced by the present building. The row of houses that can just be seen over the top of the bridge is Western View (*see page 61*). Below, Canal Bridge, Station Road, late 1930s. The view is to the west and from the opposite bank to the previous photograph. The old bridge was replaced by the present bridge in 1935.

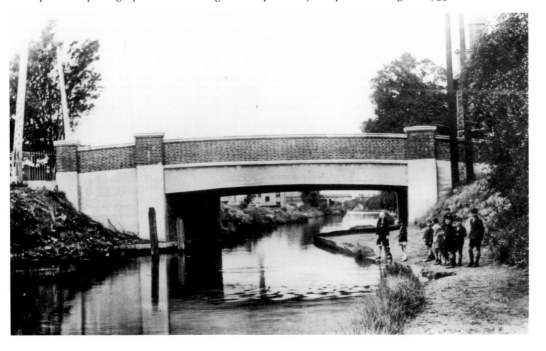

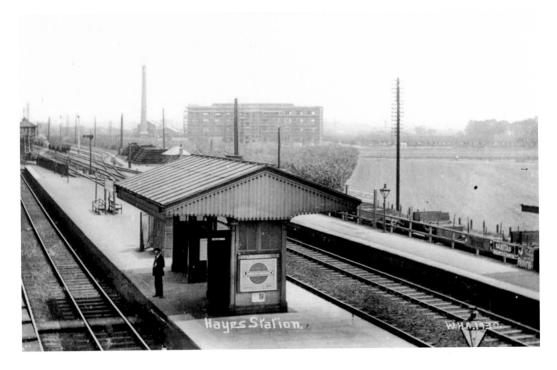

## Hayes Station

A view of Hayes station, *c.* 1914, looking towards Southall. Officially known as Hayes & Harlington station, it was opened in 1864 some twenty-five years after the neighbouring stations at Southall and West Drayton. The wide spacing between the tracks is a relic of the Great Western Railway's original broad gauge (7 feet), which was altered in 1892 to the standard gauge used by all the other railway companies. In the background Sandow's Cocoa & Chocolate factory (now part of Nestlé) is under construction. Below, the Nestlé factory building as seen from Hayes station 2012.

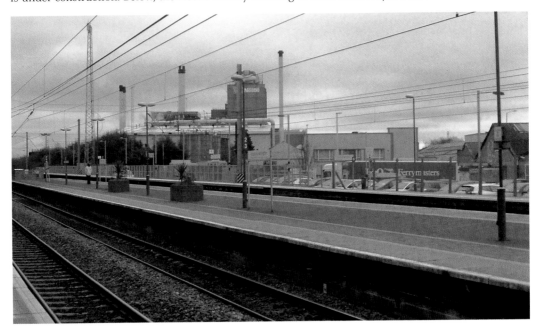

**Bourne's Bridge, Late 1930s**

The view is to the west, with the EMI factory building just in view on the right. The bridge, built to carry Dawley Road over the railway line, derives its name from James Bourne, the owner of the farmhouse that stood at the foot of the bridge at the time of its construction in the 1830s. It was demolished in the 1990s as part of the electrification of the line from Paddington to Heathrow. Below, the replacement bridge, 1996. The brick pillars of the original bridge stood in the way of electrification and had to be replaced with the bridge seen here, which crosses the railway line in a single span.

## Hayes Station Goods Yard

Hayes station goods yard, 1997. Apart from carrying the main lines between Paddington and the West Country, Hayes station had a large goods yard and also a direct rail link, which crossed Station Road by means of a level crossing to the factories on the opposite side of the road. The decline of manufacturing industries and the growth of road traffic meant that the yard became redundant and increasingly derelict. This left a large triangle of land between the main line, the canal and Station Road that was ripe for redevelopment. Below, High Point Village, Hayes station, 2012. The redevelopment of the goods yard took the form of a massive development which, according to its sponsors, is 'a private community that redefines waterside living and where style and quality come as standard. Where tranquil canal life blends into bustling restaurants and bars. And where your own private pool, spa, gym and landscaped gardens will bring new meaning to retreat – just six minutes from Heathrow airport and thirty minutes to London's West End.' In reality, the outlook on one side is the main railway line to the West Country with trains passing through every few minutes twenty-four hours per day. The other side overlooks the canal, beyond which is a large high-rise block of council flats (*see page 61*).

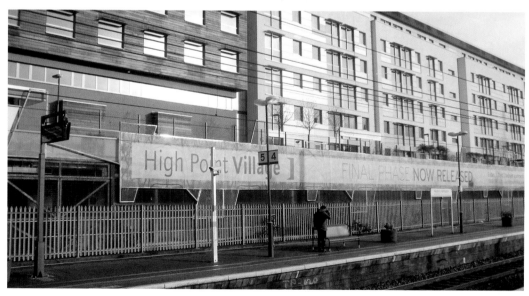

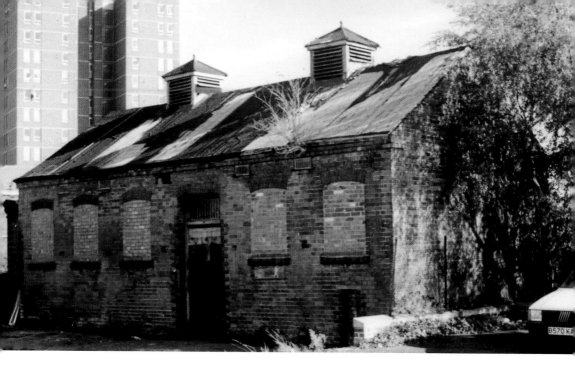

## Stables

Derelict stables at Hayes station goods yard in 1990. Until well into the twentieth century the Great Western Railway relied heavily on horse-drawn transport for local deliveries from the station. The stables had long since become redundant and were demolished to make way for the High Point Village development (*see previous page*). The large block of flats seen in the background is the main feature of the view from the canal side of this development! Below, the site of the stables 2013, which is now part of the massive High Point Village development.

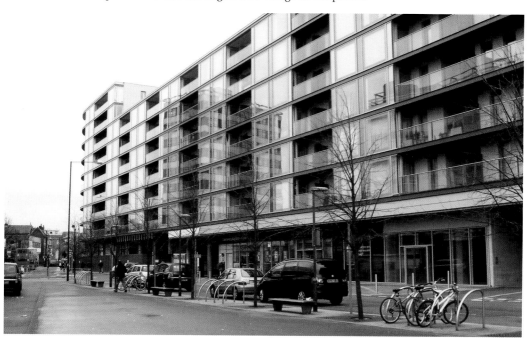

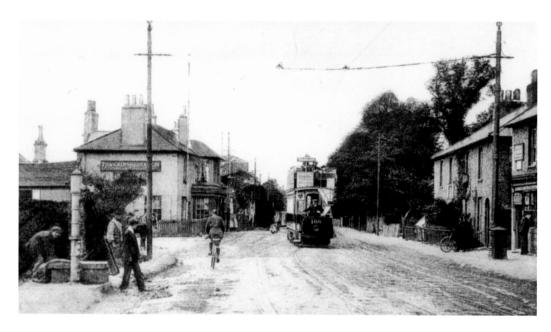

## Uxbridge Road

Uxbridge Road, Hayes End, 1905. A tram service between Shepherd's Bush and Uxbridge opened in 1904. This photograph shows a Route 100 tram of the London United Electric Tramways heading towards Shepherd's Bush. On the left is the Angel public house (*see page 44*) and just in view on the extreme right is Hayes End post office (*see page 25*). Below, trolleybuses at Hayes End in 1960. The trams along the Uxbridge Road were withdrawn in 1936 and replaced with a trolleybus service. This lasted until 1960 when the trolleybuses were in turn replaced with motor buses.

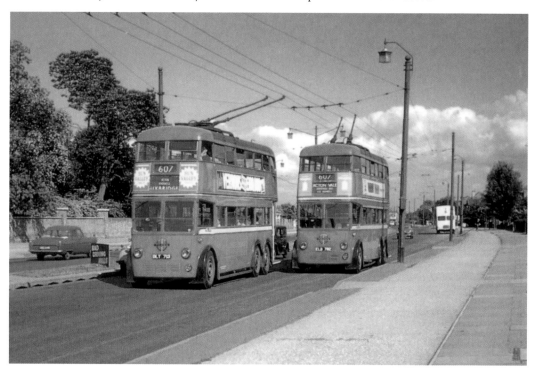

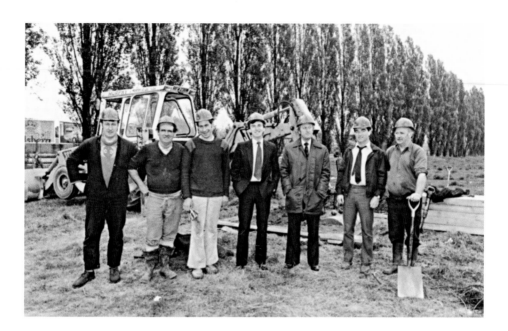

## Hayes Bypass

The ceremonial cutting of the first sod on the route of the Hayes bypass in 1985. The ceremony was performed by John McDonnell, then GLC Councillor for Hayes (and MP since 1997). He is seen here soon after performing the ceremony, standing (*centre*) with a group of workmen. The Hayes bypass, together with the Cranford Parkway with which it connects, is all that came to be built of the D ring road of the Greater London Plan. Although the need was obvious and for the most part the route was mostly open land, it was not until 1981 that the then Greater London Council voted by a majority of one to proceed with the project. Below, John McDonnell standing on the bridge over the Pump Lane interchange shortly before the bypass was opened. The road was formally opened throughout its length from the White Hart at Yeading to the Cranford Parkway by the then Minister of Transport on 29 September 1992.

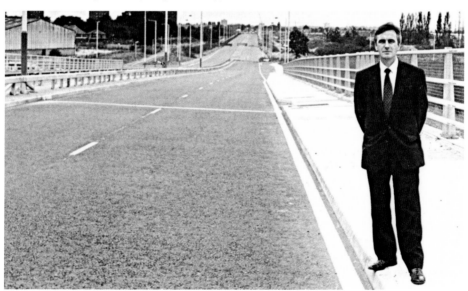

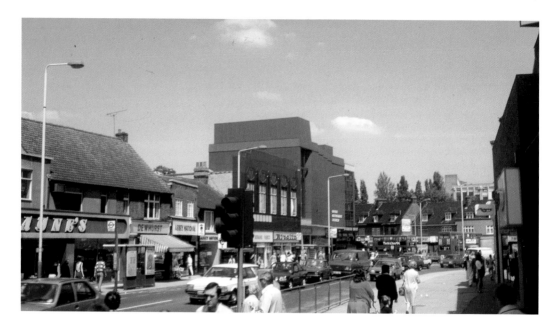

### Station Road

Station Road shopping centre, 1985. Until the opening of the Hayes bypass, Station Road was the main thoroughfare through the shopping centre. This was a great inconvenience because shoppers could only cross the road at a pedestrian-controlled traffic light. Because of the heavy traffic, parking in the road was strictly forbidden. Below, the shopping centre in 2013. The opening of the Hayes bypass in 1992 had enabled the town centre to be closed to traffic, but surprisingly it did not meet with universal acclaim, particularly from the shopkeepers who complained that it affected their trade, even though prior to closure shoppers had been unable to park their cars outside the shops! In reality the decline in trade was far more the result of the closure of the factories and the growth in out-of-town shopping centres. However, to meet the criticism the road was opened to limited traffic and parking allowed on one side of the road, though through access was still denied, but it has proved to be an unsatisfactory compromise.

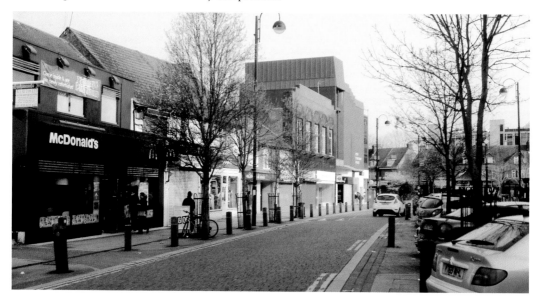

# A Voice to Remember

CHAPTER 7

# Industry

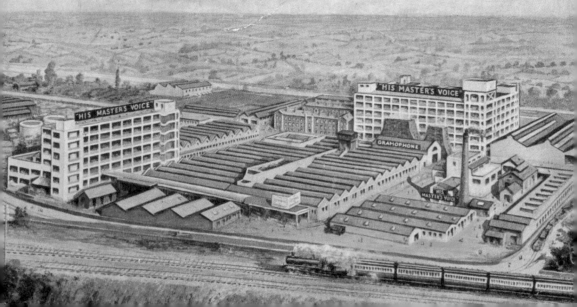

His Master's Voice

THE GRAMOPHONE CO., Ltd.

Factories: HAYES, MIDDLESEX, ENGLAND

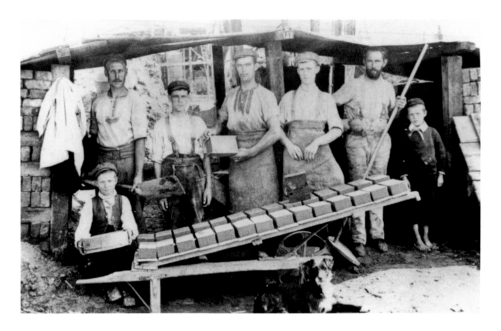

## Brickmaking

Brickmaking, Uxbridge Road, c. 1905. Brickmaking was the first major industry to appear in the locality. It followed soon after the opening of the Grand Junction Canal from Brentford to Uxbridge through Hayes in 1794. It was due to the presence of rich brickearth deposits in the areas close to the canal, which meant that bricks could be carried by barges to the London market. This photograph was taken on the south side of the Uxbridge Road, close to the boundary with Southall; between 1901 and 1960 it was worked by the East Acton brickworks. The men and boys are posing with the tools of their trade for a publicity photograph. Below, the entrance to Shackle's Dock from the Grand Union Canal. The many short branches (docks) of the canal that serviced the brickfields had to be bridged so that access along the towpath could be retained. One of the few that remains is the attractive bridge at Shackle's Dock, named after the Shackle family, who owned land and brickfields around Hayes. The plaque in the centre of the bridge was affixed in 1994 to mark the 200th anniversary of the opening of the canal through Hayes.

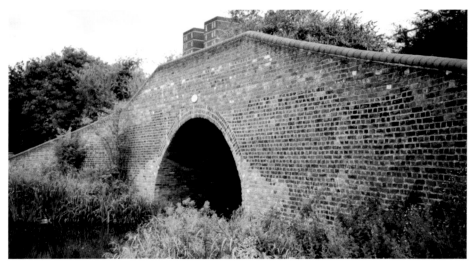

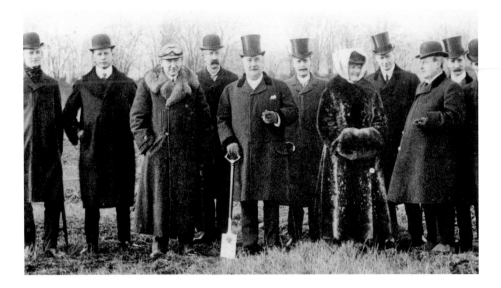

## EMI

'The interesting little ceremony at Hayes last Saturday, when Mr Edward Lloyd, the famous tenor, cut the first sod in connection with the erection of the new works of the Gramophone & Typewriter Co. Ltd, was a reminder of the fact that the industrial outlook at Hayes has become exceedingly bright of late years, thanks largely to the enterprise of the Hayes Development Co., and we have, consequently, secured full particulars concerning the various industries which have started at Hayes during the past few years.' This statement was found in an article in the 16 February 1907 edition of the *Middlesex & Buckinghamshire Advertiser*, describing the progress of the Hayes Development Company Estate. The Gramophone Company (later EMI) was by far the most significant of the companies to move to the site. It was founded in 1897 when it acquired the UK rights to produce and market the gramophones and disc recordings that had been invented in the USA by Emile Berliner. In its early years it was based in London, but in 1907 it moved to a site in-between the railway line and Blyth Road, Hayes. The photograph shows building work in progress; typewriters had been made by the company for a short time as a hedge against the failure of the gramophone, but this fear proved to be unfounded and the company soon reverted to its original name.

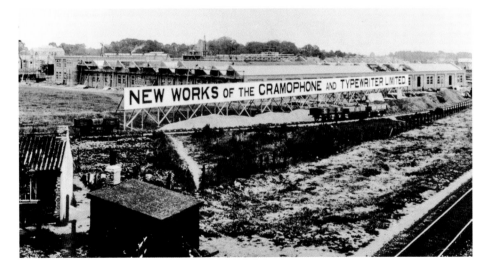

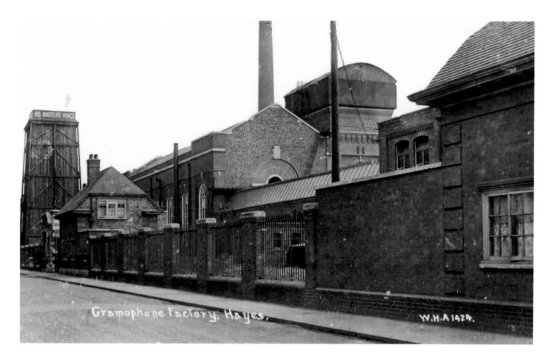

Gramophone Factory, Hayes.    W.H.A 1424.

## The Gramophone Company

This photograph from the early 1900s shows the first factory buildings of the Gramophone Company soon after completion. In 1899 the company had commissioned the artist Francis Barraud to modify his painting of a dog listening to a phonograph playing a cylindrical record of 'His Master's Voice'. The modification showed the dog listening instead to a disc recording playing on one of the company's gramophones. This became the registered trademark of the Gramophone Company, and achieved such fame that the company became better known by its trademark and the initials HMV. Below, the original buildings of the Gramophone Company in Blyth Road, 2012. Remarkably the buildings seen in the upper photograph still survive. Earlier plans for the redevelopment of the EMI complex envisaged their conversion into a restaurant but apart from the refurbishment of two of the large factory buildings they came to nothing. Fresh plans for the redevelopment of the site are currently under consideration.

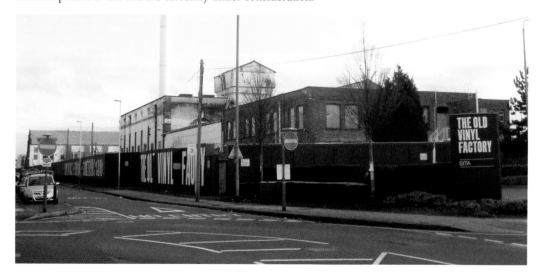

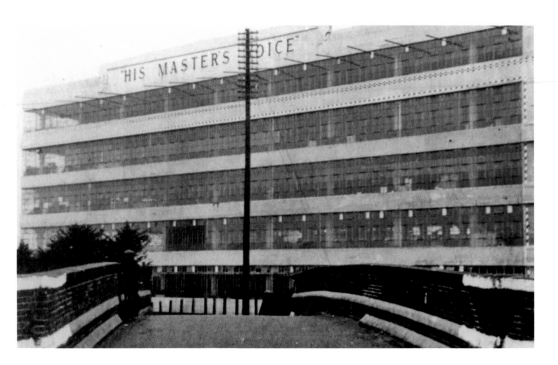

**Bourne's Bridge**

Above, the HMV/EMI factory building on Bourne's Bridge, in a photograph dating from the early 1930s soon after the factory was built. Below, the same building, photographed in 2003, after refurbishment as office accommodation. The open-plan nature of the floors of the factory building meant that it could easily be redeveloped to provide floor space that could be sub-divided into offices. The photograph shows that all of the main features were preserved and the building remained as a landmark on the bridge. The old Bourne's Bridge was a dangerous bottleneck and it was completely rebuilt in the early 1990s to allow for the construction of the Heathrow–Paddington railway link; however, no attempt was made to straighten the road at the same time.

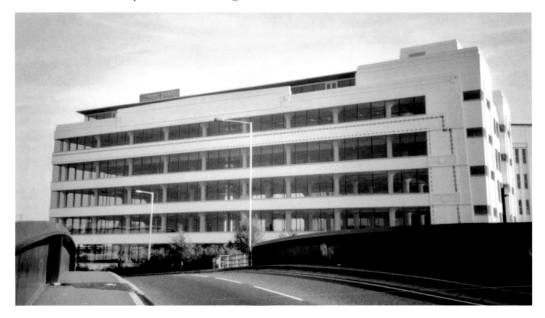

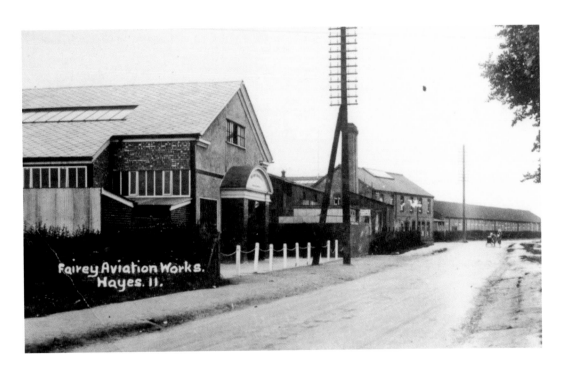

## Fairey Aviation

Fairey Aviation Company's premises, North Hyde Road, 1930. The company was founded by (Charles) Richard Fairey in 1915 and began life in premises leased from the Army Motor Lorry Company in Clayton Road Hayes. Disputes between the companies led Fairey to do a 'Moonlight Flit' in which, overnight, he removed all of his equipment from Clayton Road to a site that he had acquired in North Hyde Road, Harlington. This site was subsequently developed as the headquarters and factory of the company. Because the company started life there the Hayes address was maintained, although strictly speaking it was in Harlington. Below, the former main office building of the Fairey Aviation Co., North Hyde Road, in 2004. This was built in the 1930s, and at the time the photograph was taken it was the only building of the company that still stood on the site. However, it too has since been demolished.

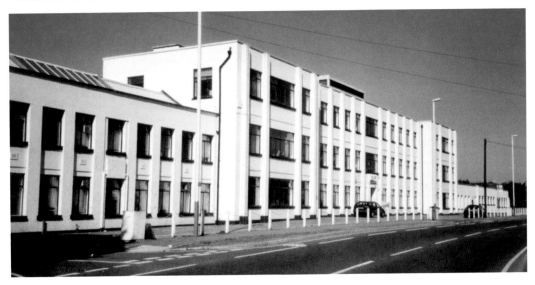

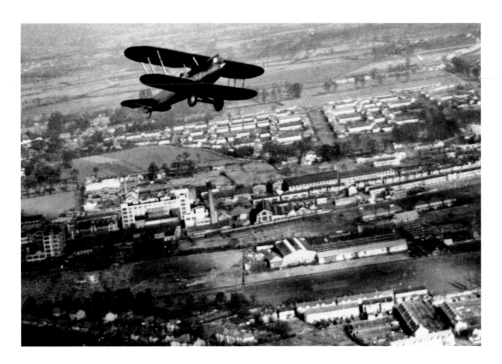

## Fairey's Aircraft

Above, one of Fairey's aircraft flying over the company's premises in the early 1920s. Below, a Fairey Rotodyne flying over the premises *c.* 1960. The Rotodyne was a helicopter designed and built by the company and intended for commercial and military applications. It featured a tip-jet-powered rotor that burned a mixture of fuel and compressed air bled from two wing-mounted turboprops. The rotor was driven for vertical takeoffs, landings and hovering, as well as low-speed translational flight, and auto-rotated during cruise flight with all engine power applied to two propellers. Although promising in concept and successful in trials, the Rotodyne programme was eventually cancelled because of the lack of commercial orders arising from concerns over the high noise levels. The noise produced was said to be such that from 2 miles away it could make conversation impossible.

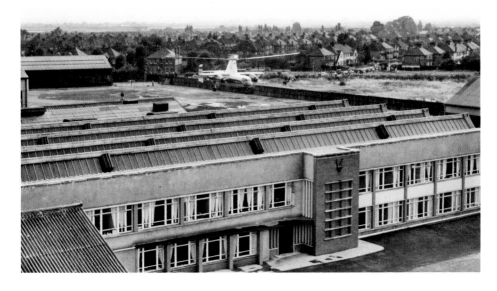

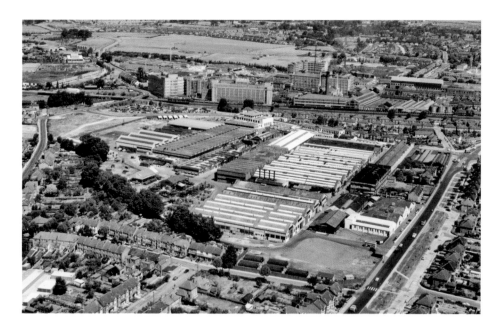

## Fairey Aviation Site

The Fairey Aviation Company, *c.* 1950; an aerial view of the factory after it had expanded to its fullest extent so as to occupy most of the land bordered by Redmead Road, Station Road, North Hyde Road and Dawley Road. The loss of its aerodrome at Heathrow was a severe blow to the company, particularly as it did not receive compensation for this loss until twenty years after it had been requisitioned! By then it had been taken over (in 1960) by Westland Helicopters, which closed the Hayes site in 1972 and moved its operations to Yeovil. Below, the site of Fairey Aviation Company in 2012. After the Fairey works were closed down by Westland in 1972, the site was redeveloped as an industrial estate mostly comprised of warehouses belonging to firms such as Marks & Spencer, Safeway, Hitachi and Mercedes Benz. By 2000 very few of the firms remained and most of the warehouses were demolished apart from a few on the northern half of the site. These remain together with a large warehouse belonging to Nippon Express, which now occupies the area close to Redmead Road. However, most of the site was still vacant in 2012, although plans were being made for the development of a large supermarket.

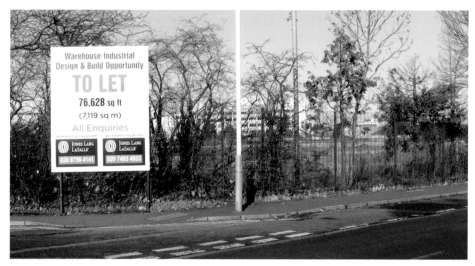

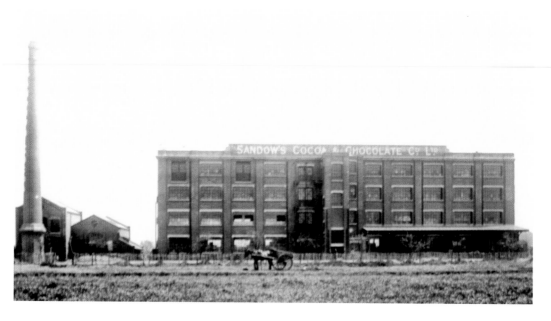

## Chocolate

Sandow's Cocoa & Chocolate factory soon after its opening in 1914. The company was founded by Eugene Sandow, a fitness fanatic and circus strongman who became convinced that cocoa contributed to health and strength. He opened a cocoa-processing factory in London and, wishing to expand, acquired a site in Hayes to build a factory that opened in 1914. Some years later the company went into liquidation and was renamed as the Hayes Cocoa Company. It was eventually taken over by Nestlé in 1929 and greatly expanded to its present size. Below, Nestlé's chocolate factory. This aerial view from the early 1930s shows the original darker-coloured Sandow factory with the major addition made by Nestlé around it. The factory had good transport links to the railway and the canal.

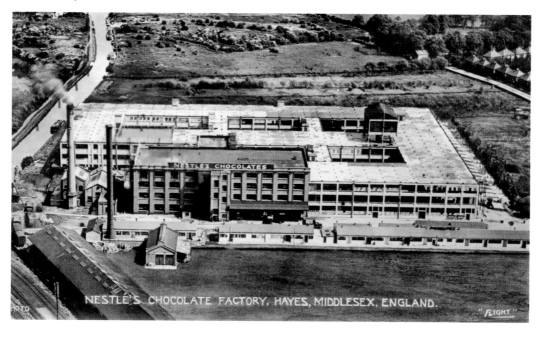

NESTLÉ'S CHOCOLATE FACTORY, HAYES, MIDDLESEX, ENGLAND.

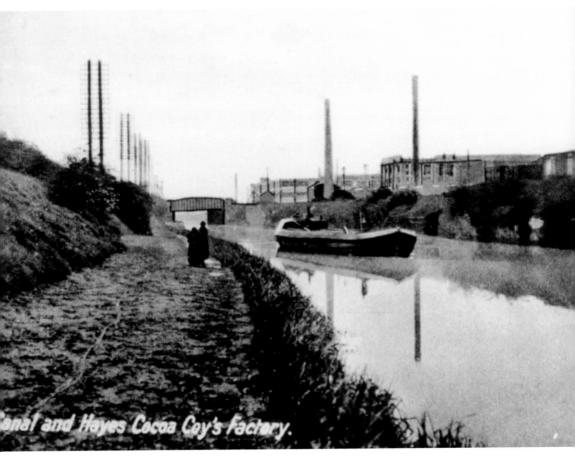

Canal and Hayes Cocoa Coy's Factory.

**Chocolate**
Above, Hayes Cocoa Company as seen from the canal in the early 1920s. Left, Nestlé's factory as seen from the canal in 2003. On the far left is the bridge over Shackle's Dock (*see page 76*) and in the middle distance of both photographs is the railway bridge over the canal.

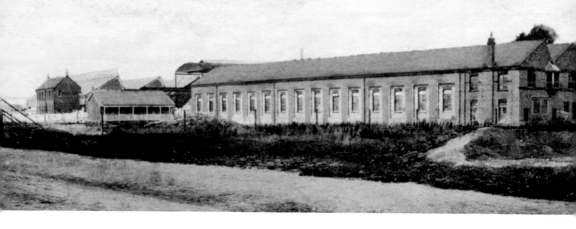

## BET Factory

The British Electric Transformer Co., Clayton Road. This photograph shows the original works in Clayton Road in the early 1900s. The company was one of the first to occupy the land acquired by the Hayes Development Company. It moved there in 1901 and, in explaining the reason for making the choice, said, 'The question of transport, both for incoming and outgoing finished goods, received very careful attention before the Hayes site was finally decided on. As a result there are three methods of approach available, that is by road, rail or water.' Below, an aerial view of Botwell around 1932 with the BET factory in the centre. The canal runs diagonally across the lower half of the photograph and the railway line can just be seen in the left-hand corner. Between BET and the railway are the houses on the south side of Clayton Road and the north side of Blyth Road, which were built at the same time as the factories to accommodate the workers. On the other side of canal to BET is Harrison's printing works.

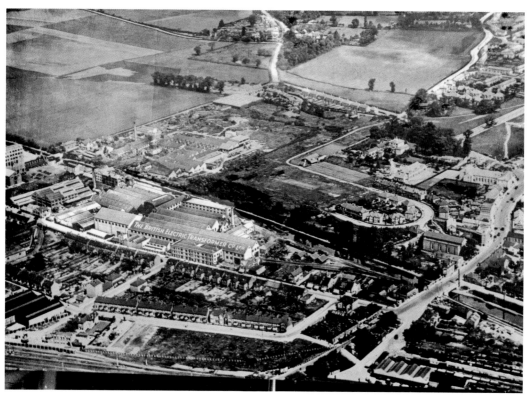

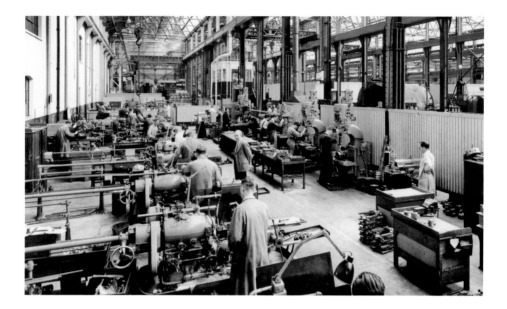

### Factory Interiors

Above, the interior of the BET factory, and below, the interior of Fairey Aviation's factory. Many photographs of factory interiors of EMI, BET, Fairey Aviation, etc., taken at the time look very similar, the only difference being the end product. Manufacturing industry of this type has completely disappeared from Hayes. The photographs well illustrate the sheer back-breaking drudgery of factory work at that time. Workers started work at 7.30 a.m. and were on their feet all day until 5.00 p.m. (12 noon on Saturday) with a short break mid-morning (which was then called lunch), a longer break at midday (then known as the dinner break), and another short break in the afternoon for a cup of tea. Factory sirens (hooters) summoned people to and from work. These were not synchronised so at times like 5.00 p.m. there was a cacophony of sirens blasting out from the various factories in Hayes. Although the profits of a company ultimately depended on the 'industrial' staff, they were treated much worse than the office workers who were regarded as the real 'staff'. They had separate (and inferior) canteens and their terms of employment were such that they could be dismissed at short notice without pay at slack times and taken on again when work picked up.

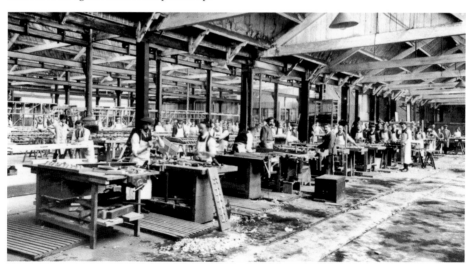

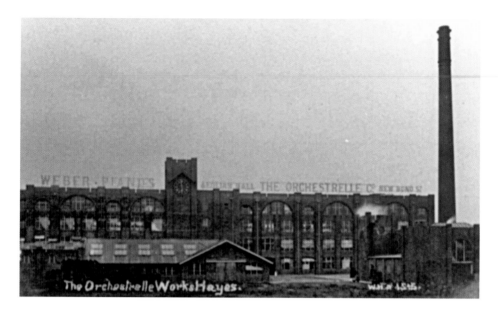

The Orchestrelle Works Hayes.

## Aeolian Company

The Aeolian Company's factory in Silverdale Road, c. 1910. The Aeolian, Weber Piano & Pianola Company of Massachusetts traded in Great Britain under many names including the Aeolian Company, the Orchestrelle Company and the Weber Piano Company. In 1909 it opened a factory in Silverdale Road, and this photograph shows the factory, as seen from the railway line, shortly after it was opened. The main products of the company were mechanical piano players that, before the days of recorded music and the radio, were popular forms of home entertainment. In 1912 the company became semi-independent of its American parent, with its registered office at the Aeolian Hall in New Bond Street and its factory in Hayes. The company gradually expanded its activities in Hayes, but all of its buildings except for this original have been demolished. The central tower of the building was not just an architectural embellishment but was used for hanging the music rolls at full length during the manufacturing process. The photograph below shows that, surprisingly, the original building (known as Benlow Works) still (in 2012) survives, although in a derelict state. It is in fact a fine red-brick building (Grade II listed) and well worthy of preservation as an example of early twentieth-century industrial architecture in Hayes. Below, the former factory building (Benlow Works) of the Aeolian Company in Silverdale Road in 2012.

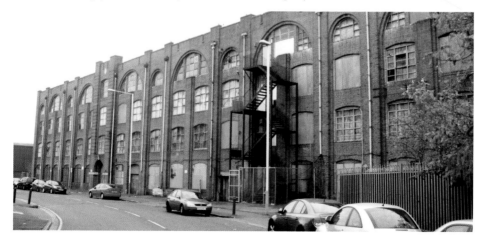

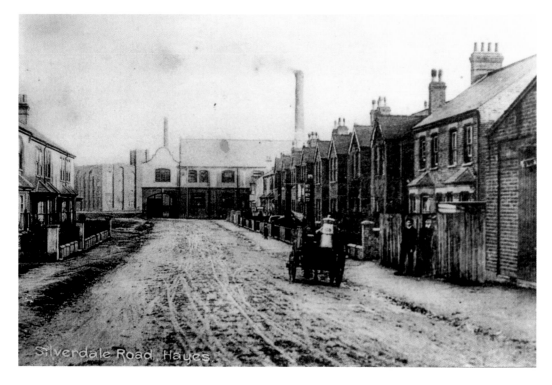

Silverdale Road, Hayes.

### X-Chair Company

The X-Chair factory in Silverdale Road was one of the first factories to arrive in the area of Silverdale Road. It was founded in 1897 and opened its factory in Hayes in 1907. It closed down in 1948, but the factory buildings seen in this picture still remain and form part of the Silverdale Road industrial estate. To the left of the X-Chair factory is the original building of the Aeolian Company. Below, the X-Chair Company's exhibition stand at the British Industries Fair, 1934.

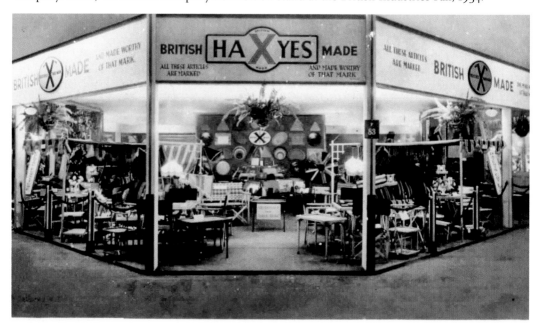

CHAPTER 8

# Hayes at War

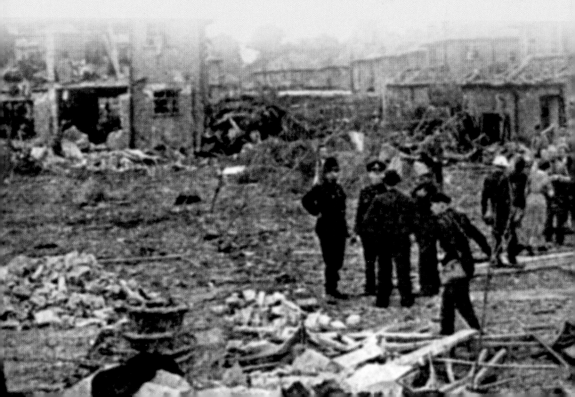

# Hayes

## Verstell-Luftschrauben-Werk Fairey Aviation

Länge (westl. Greew.): 0° 25′ 30″   Breite: 51° 30′ 00″

Mißweisung: − 10° 36′ (Mitte 1940) Zielhöhe über NN 30 m

Maßstab etwa 1 : 17 500

Genst. 5. Abt. Oktober 194

Karte 1 : 100 000

GB/E 34

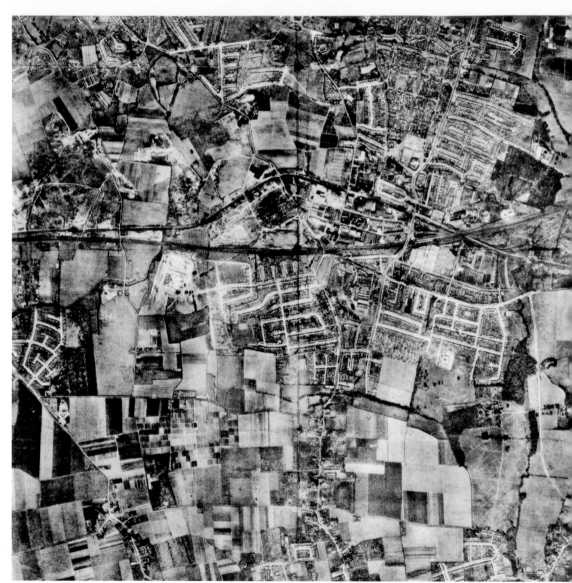

Aerial View

An aerial view photographed during the Battle of Britain by the Luftwaffe on 5 October 1940. The photograph was clearly taken to identify the location of Fairey Aviation's premises and the factory was later the subject of a dive-bombing attack. The southern part of the photograph shows the villages of Harlington (in the centre) and Sipson (on the left) surrounded by fields in intensive cultivation.

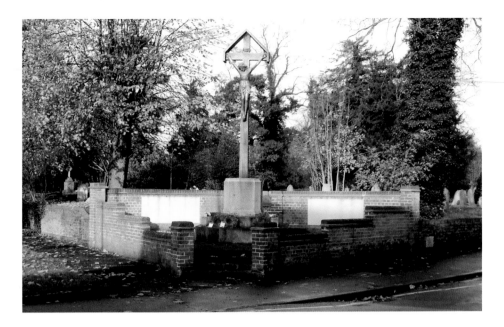

## Hayes War Memorial

Hayes War Memorial, Church Road. Ninety-one men from Hayes parish were killed in the First World War, and to mark the tragedy this memorial was erected soon after the end of the war. It records the names of those who were killed. Further names were added in the late 1940s in memory of those killed in the Second World War. Below, the war memorial, Cherry Lane Cemetery. The worst incident in Hayes in the Second World War occurred in the afternoon of 7 July 1944 when a V1 flying bomb hit one of the surface air-raid shelters of the Gramophone Company (EMI). The monument records the names of the thirty-seven people killed in the incident, twelve of whom were buried together in the cemetery.

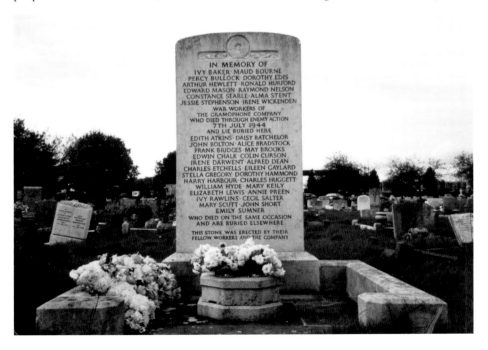

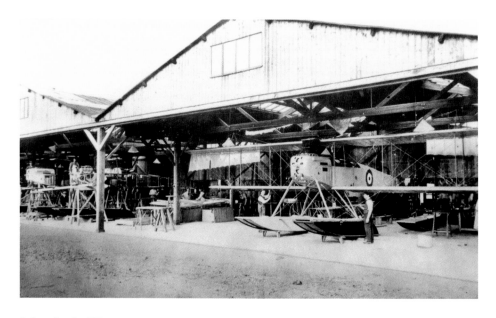

### Fairey in the War

Fairey Aviation Company's premises in North Hyde Road, 1917. The company was founded during the First World War (*see page 80*) and throughout its existence most of its work was concentrated on the manufacture of military aircraft. This photograph shows a Campania seaplane almost ready for delivery. Below, Fairey fighter aircraft, North Hyde Road, 1917. One of the First World War fighter models was produced by Fairey's. This example is standing in a field in North Hyde Road next to the company's factory. This ungainly beast, based on an Admiralty specification, would have had little chance against the more agile German fighters of the time. The view is to the north with the hedgerow of the road in the background and the ghostly silhouette of the Gramophone Company's multistorey factory (now Enterprise House) in Clayton Road. Fairey's flight trials initially took place from this field, but as the factory expanded it became too small for use. Later it obtained permission to use the RAF aerodrome at Northolt for its trials. When this permission was revoked it developed its own aerodrome at Heathrow in 1929, only to see this requisitioned by the Air Ministry in 1944 thus beginning the slow decline of the company.

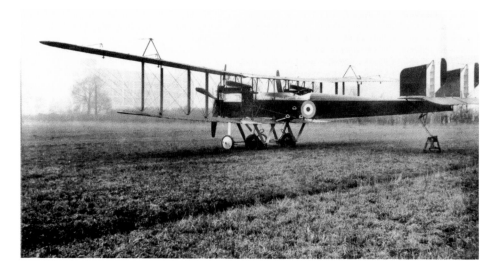

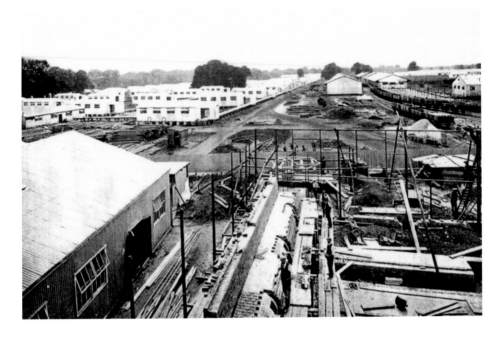

**No. 7 Filling Factory, Hayes**

This factory was one of a number built in 1915 at the instigation of Lloyd George, Minister of Munitions, to augment supplies of shells for the Army. It occupied a large area of land from the railway almost as far south of where the M4 is now. The sheds were widely separated and connected by wooden walkways to reduce the risk of explosions. Below, munitions workers at the filling factory, 1917.

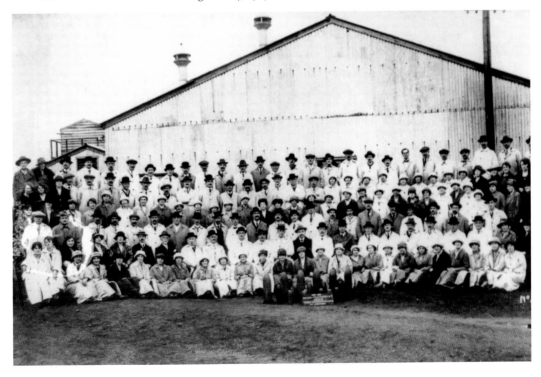

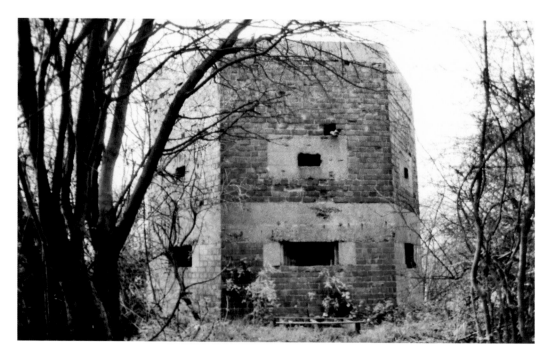

## Pillboxes

Following the threat of invasion in 1940, pillboxes such as these were erected across the country to protect areas of strategic importance, and many survive because they are difficult to demolish. The two shown here are respectively in the grounds of the Royal Ordnance factories at Yeading (*above*) and in Bourne Avenue (*below*). The pillbox at Yeading is unusual in that it is a double-decker.

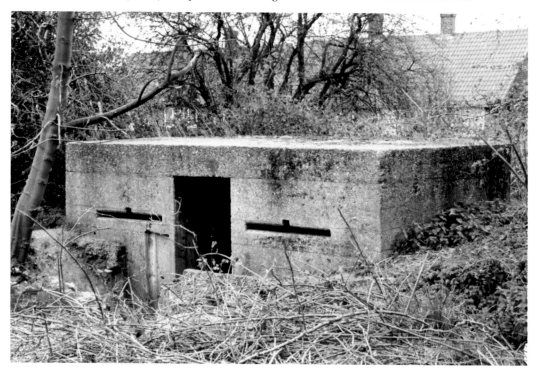

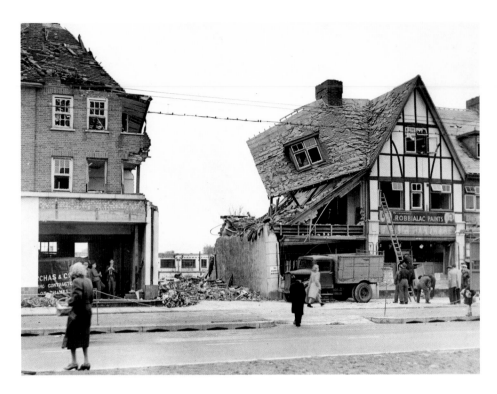

## Crown Parade

Crown Parade, Uxbridge Road, 1944. This was the scene shortly after a German V2 rocket had fallen behind the in Gledwood Drive at 1.15 a.m. on 21 October 1944. It created a 50-foot crater and did much damage although, surprisingly, no one was killed. There were, however, sixteen serious and forty-one minor casualties. Some houses had to be demolished and replaced later but the shops were repaired. Below, Crown Parade in 2012. No evidence now remains of the devastation that occurred some seventy years ago.

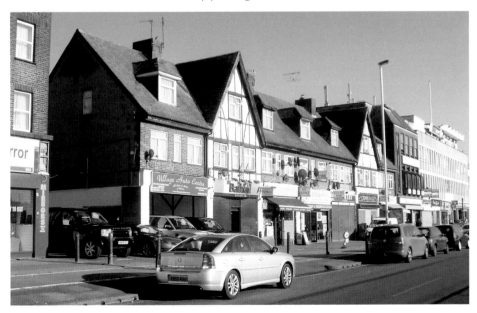

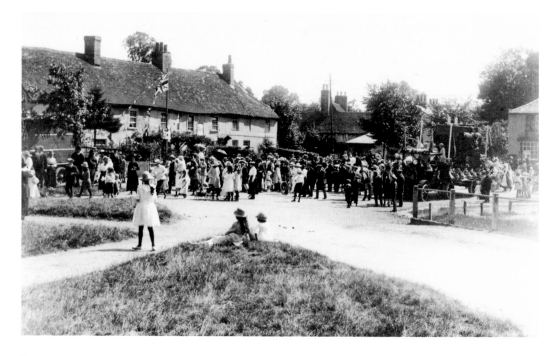

## Peace

Peace celebrations, Wood End, 9 August 1919. The end of the First World War, in which ninety-one men from Hayes lost their lives, was celebrated the following year. A procession marched round Hayes from Clayton Road via Station Road and Uxbridge Road to Wood End, where a fairground had been set up with a roundabout, swings and other entertainments. Below, the VE party, East Avenue, 1945. The war in Europe ended in May 1945, although the war in the Far East was to continue until August. However, such was the relief that street parties such as that seen here were held across the country.

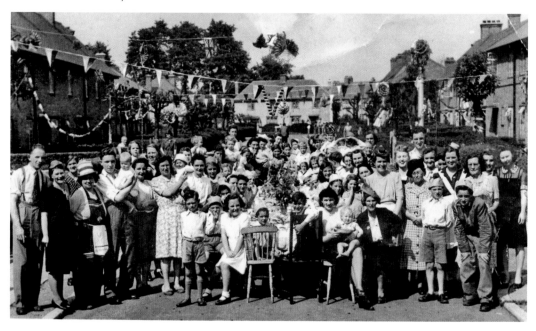